152

PENTAX

AND

SINGLE-LENS REFLEX

PHOTOGRAPHY

BY

ROBERT FUHRING

AMPHOTO

American Photographic Book Publishing Co., Inc.
New York

Contents

All photographs unless otherwise credited are by the author

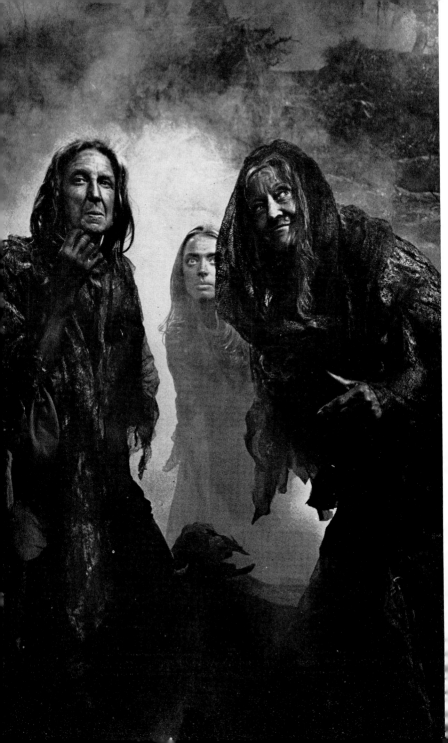

Introduction

THE SINGLE-LENS reflex camera in the past few years has opened up an exciting new kind of photography in which one sees just what a lens does while taking a picture. It gives a simple, direct and simultaneous view of all the elements that go into composing pictures. You can frame tightly and precisely in the viewer, make objects at different distances line up with each other exactly as you want them, view the depths-of-field that result from different apertures and distances, and see the varying creative effects of different focal lengths of lenses.

This single-lens viewing in the Honeywell Pentax leads to many creative advantages that are dealt with in the early chapters of this book. Today these advantages and simplicities can be matched in the other areas of 35mm photography. New films enable us to get sharp negatives capable of huge enlargement, and to take pictures in extremely low existing light. We can now add controlled light quite simply and achieve elegant yet natural effects. Equipment can be kept simple yet versatile. New techniques, and cameras like the new Pentax Spotmatic and other new Pentax models, are helping to close the gap between amateur and professional.

Beyond explaining the mechanics of a camera, therefore, I have tried to suggest ways of achieving simplicity with versatility, and naturalness with high quality. These themes are woven into the story of the Pentax quite logically, because this camera also brings back on the single-lens reflex level the original simplicity and versatility behind the 35mm idea.

After ten years of using single-lens reflexes almost exclusively I arrived at the Honeywell Pentax as the best all-

Seeing through the lens of no-parallax Pentax made it possible to catch just enough of pretty witch's face in background of this scene from Hallmark's "Macbeth." Photograph for *Life.*

around camera of this type, which to me means the best 35mm camera. This explains the ardor of Chapter I.

With the introduction of the Honeywell Spotmatic in 1965 we have a Pentax with an internal meter, a basic advance that gives the photographer all he needs to know in one viewfinder window. The Pentax Spotmatic model, with its advanced craftsmanship and superb new lens, is dealt with in Chapter III. This fifth edition has also been revised to include the many new Takumar and Super-Takumar lenses, including zoom, macro and bellows lenses and several new telephotos.

I hope to show that with the Pentax you can tackle a broader range of subject matter, at more reasonable cost, than with any other camera system.

There will be some discussion of finding subject matter worthy of a fine instrument. The emphasis will be on human interest, people in all their natural variety. This is the kind of photography which, I believe, is the most interesting to both the amateur's friends and to the professional's customers.

One may want merely to take better snapshots, or aspire to take pictures that will win double-takes from the readers of *Look* and *Life* (many of whose staff photographers have Pentaxes in their kits). In either case, viewing through the actual lenses of the Pentax gives the most direct way of seeing and recording, of being ready for the widest variety of situations, and of advancing to surer and more imaginative photography.

An unusual number of talented magazine and newspaper photographers have come to use the new Pentaxes, and their reasons should also be reasons why any serious photographer will want to consider this camera. Pentax prices, downright modest in view of quality and performance, also bring the highest standards within reach of many more photographers.

The photographs in this book were made with the Pentax, even those *of* the Pentax. In making a selection, photographs were particularly sought which could have been made by anyone without press pass or special privilege, even though this deprives the book of pictures of Brigitte Bardot at her pool. All uncredited photographs were made by the author, most of them for this book, with all recent models of the Pentax.

It has been taken for granted that anyone considering

a camera like the Pentax knows a few things, such as how an exposure meter is used, even if one is not expert at using it; that ASA numbers refer to film speed on which exposure is based; that aperture, f-number and lens opening are the same thing. In other words, the information found in the simplest direction slips is not labored.

Experienced photographers will have to bear with A-B-C descriptions of the operation and mechanics of the Pentax. These are covered in precise and thorough detail, but it is hoped that they have been sprinkled with some helpful tips and insights, even for the knowing ones.

Honeywell Photographic Products has been most helpful and cooperative. Honeywell technical personnel have checked the mechanical and technical descriptions in the book. However, that company is naturally not responsible for the many opinions expressed; it may not agree with some of them.

Many people have contributed discussion and clarification. Special thanks are due to Myron Ehrenberg, Marvin Koner, Martin Forscher, Merwin Dembling, Charles Reiche of Scope Associates and Lee Jones of Magnum Photos. I must go back over 12 years to express gratitude to Fons Iannelli, from whom I first learned to simplify techniques, strive for uncompromising quality and then to go unencumbered after the pictures. Judy and Jane were rewarding but unrewarded models.

<div align="right">Robert Fuhring</div>

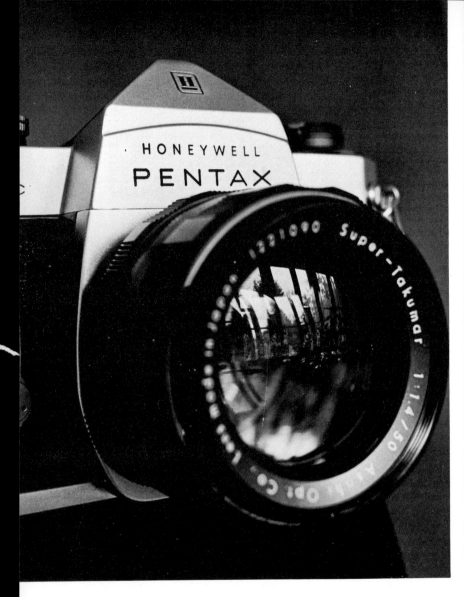

Four single-lens advantages are demonstrated in "portrait" of one Pentax by another. Reflections of sun in lens were seen and controlled. Seeing exact depth showed that letters on far side of lens and on camera body were both sharp. Unwanted reflections on chrome were seen and avoided. Absence of parallax prevented front of lens from obscuring letters on body.

4

Why the Pentax and Single-Lens Reflex?

THE MANY BEAUTIES of viewing through the taking lens of a camera instead of through a separate optical system have made the single-lens reflex the most popular kind of fine camera bought today. Some of these beauties are simple and obvious; with growing familiarity such viewing continues to disclose more subtle advantages.

Seeing through your lens of course prevents parallax problems, frees you from focusing and viewing in separate finders, and eliminates the need to change finders to match different focal lengths of lenses. You see the actual depth-of-field, or zone of sharp focus, as you shoot.

Whether you attach the longest telephotos, use extensions for ultra-close-ups, mount your camera on a microscope, or play with supplementary lenses, the same viewfinder window always shows the picture that the lens will transmit to the film. One of the small bonuses in single-lens viewing is that you are prevented from taking pictures with a lens cap or a wrong filter over your lens. It is possible to focus much closer than you can with a rangefinder camera.

Beyond these are further superiorities of seeing as each lens does, and controlling precisely what the film will record. The rangefinder camera or twin-lens reflex cannot relate near and far objects so exactly to each other as the single-lens reflex. They cannot easily avoid unwanted highlights, reflections from shiny surfaces (as when shooting through glass) and flares (as when aiming toward the sun or bright lights), nor can they make use of them creatively in the precise way that single-lens viewing does.

The single-lens reflex enables you to do tricks with multiple-mirror images without guesswork; shoot through latticework, bars, mesh yet line up both of a subject's eyes in the open spaces; center a zoo lion in one frame of his wire cage; catch a delicate expression on a face seen only partially from behind, or partly blocked by a shoulder—and each of these comes out precisely as viewed, not at some

different angle as it does when separated viewing and taking lenses see from different angles.

The out-of-focus areas in photographs are an important part of composition, whether slightly or completely unsharp, forming indefinite patterns or blobs of light and dark. Again, only in single-lens viewing can you see them and use them.

A frequent use of wide angle lenses is in composing so that something in the foreground is related to something farther away; only a single-lens reflex does this precisely. With other systems, this parallax problem increases at close distances, at which wide angle lenses magnify it further: with them each small shift of the camera results in greater shifts between objects at different distances.

Particularly in the Honeywell Pentax, you view and focus in a finder that is unusually and evenly bright out to the corners, with a critical focus spot in the center that does not darken or go black when you stop down and thereby detract from composing the picture. You change focus, advance film and cock the shutter, and then trip the shutter, without taking your eye from the finder. With automatic and preset lenses, like most of the Pentax Takumars, you do not have to open up for focusing and then take your eye from the finder in order to close down again to the proper taking aperture.

But more important than these separate advantages is the way in which the Pentax merges them all into one quick, smooth action. You focus, compose, follow action or expression and trip the shutter with the least mechanical distraction or concern over whether everything is properly set. These steps soon become unconscious habits, leaving you free to concentrate on the pictures.

Further along in this chapter we'll see how the Pentax is designed to become this extension of your eye and hands, a part of yourself, and what it can lead to in pictures. The Pentax is a tool that ideally brings to single-lens reflex work the classic idea behind 35mm photography: a fast, functional and flexible box for seeing and capturing what is seen. Its feel in the hands is that of a fine instrument asking to be used. Its beveled corners fit snugly into the palms, and each operation falls under the proper finger in the right and logical sequence. It is the most compact and light in weight of its type. Looking down on the top of it you see in one glance everything necessary to shooting: speeds, apertures, distance and depth-of-field scales, number of frames exposed, whether the shutter is cocked, and what type of film is loaded.

Backed by Honeywell

The various models of the Pentax, its lenses and accessories are made in Japan by the Asahi Optical Company and imported, guaranteed and serviced nationwide by Honeywell Photo Products, a division of Honeywell, Inc. Asahi, a leading designer and maker of high quality optics in Japan for some 45 years, introduced the first single-lens reflex there in 1951 and invented the instant-return mirror in 1954. Honeywell-Heiland ended a worldwide search for a camera of top professional quality and "best seller" potential when it found Asahi and its earlier Pentaxes; the two collaborated in designing and launching the H–2 model in 1959, the H–1 and H–3 in 1960, the H–1a and H–3v in 1963, the Pentax Spotmatic in 1965 and the SL in 1969.

This unusual combination of a foreign camera manufacturer with a large and experienced American corporation provides the Pentax owner with excellent service through Honeywell's many depots and Denver Service Center, and immediate follow-through on the 12-month guarantee. It also puts Pentax equipment through a double testing: the optics and mechanics are first rigidly tested by Asahi, and then each lens and camera that bears the Honeywell name is thoroughly-checked out by that company.

A basic box

The virtues of omission in the Pentax are significant of the restraint that has kept its designers from cluttering up the camera with gadgetry that would add to its weight and clumsiness, raise its price and increase its mechanical complexity. As an example, none of the Pentax models has a waist-level finder, a device which makes vertical pictures almost impossible, requires you to bob your head up and down to follow action, in which it is difficult to focus accurately, and which reverses the right and left of your image. Instead, the eye-level pentaprism is built in so that it is kept permanently aligned and dust-free. (A right-angle accessory finder is available; it enables you to shoot out of tight corners, at waist-level or floor-level, and is useful in scientific and close-up work like macro- and microphotography.)

On the Pentax there are no speeds slower than one second; the photographer is better off timing these himself at

Time or Bulb than carrying around excess, expensive machinery which may not remain accurate and adds to the weight and complexity of his camera. There is no built-on bulky exposure meter, but there is an excellent small and sensitive battery meter which couples easily to the shutter speed dial and can be left on the camera or used separately as you wish. The Spotmatic, of course, has an internal meter.

What you have left in your hands is a superb and rugged machine that can do almost everything in 35mm photography, and do it with the highest quality. Yet the system allows you to add a host of features of your own choice.

Major Pentax features

The Pentax H–1a has eleven shutter speeds from one second to 1/500 second, plus Time and Bulb. The H–3v and the Spotmatic also have 1/1000.

All of these speeds are on a single dial which does not have to be lifted for turning, and can be turned in either direction to reach a desired speed. The dial does not rotate when the shutter is tripped, as on some other cameras, so that you cannot spoil an exposure if a finger happens to rest on the dial. The dial speeds can be set before or after cocking the shutter, and they are in the same position at both times.

The Pentax shutter speeds are printed in a large and legible white on black, with 1/50 second electronic flash setting as a red "X" and Time (T) and Bulb (B) in green. It seems such a simple device, but check its many simplicities against other speed dials. The Spotmatic's electronic flash synch is 1/60 second; it lacks the (T) setting.

The standard lens on the new SL is the tack-sharp 55mm f/1.8 Super-Takumar with a fully automatic diaphragm. This fine lens has click-stops and half-stops to f/16. Before shooting, the diaphragm or aperture ring is set to a selected f-number, but your view retains the brightness of the widest aperture. As you press the shutter, the diaphragm automatically closes down to the desired setting, then springs open again to full aperture for focusing the next picture. The lens focuses to a close 18 inches. It also comes on the Spotmatic.

The less expensive H–1a now comes with an almost identical lens, a fully automatic Super-Takumar that opens to f/2. The f/1.8 lens can be bought on a Spotmatic body at an in-between price.

The Spotmatic also has a new-formula 50mm f/1.4 Super-Takumar lens discussed in Chapter III.

All Pentaxes have fast, smooth, non-jarring instant-return mirrors, so that the image does not stay blacked out after you trip the shutter. Film is advanced and shutter cocked simultaneously by a short, single stroke of a lever which prevents double exposure. On this lever is mounted the automatic frame counter. The lever can be operated very rapidly without taking your eye from the viewfinder. A red indicator shows when the shutter is cocked, but the lever itself locks back; you can also tell that you are cocked just by feeling the lever. A fold-out crank on the rewind knob allows very rapid unloading. The rewind button will stay depressed until the entire roll is rewound. A reminder dial can be set to show speed and type of film that is loaded. All models have separate flashbulb and electronic flash terminals.

On the sides of the viewing window are grooves that accept various attachments. An accessory clip fits into these grooves and holds lightweight flash units. The grooves also hold the 90° angle finder and a special prescription eyepiece.

Bright Pentax viewing

The design behind the viewing system of the Honeywell Pentax is unique, but unless it is compared with other cameras it can hardly be appreciated. Like some others, it has a fresnel lens to take the image from the reflex mirror and greatly brighten it as it enters the system of prisms. These prisms reflect the image to the eye so that it is right side up, and the right and left sides of your view are not reversed, as they are in twin-lens reflexes and waist-level finders. This fresnel lens in the Pentax gives not only an extremely bright image—but all that shows is a series of quite *faint* concentric lines in the viewer; in other cameras these circles can be bold and distracting, making it difficult to compose, judge depth and to see exact focus outside the center focusing spot.

On the H–3v and Spotmatic, the central microprism breaks up the out-of-focus image into a pattern of shimmering dots, while the H–1a shows parallel diagonal lines. As soon as you are exactly on focus, these dots or lines disappear and the image snaps into positive sharpness. This focusing really should be seen and compared with others. Until the new Pentaxes came along I resisted other focus spots, some with split image rangefinders, and even had them removed from previous cameras, because they were so definitely marked that they interfered with composing.

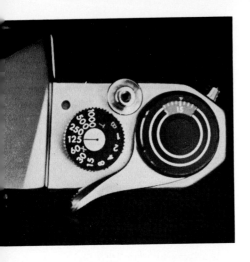

Foolproof shutter speed dial, shown at left on an H–3v; the H–1a lacks only the 1/1000. On right is new self-setting frame counter. Top center is shutter release button; top left, window that indicates when shutter is cocked. The Spotmatic is shown in Chapter III.

A word should be said here for those who have been using rangefinder cameras for a long time. You may feel a temporary resistance to single-lens focusing before you can appreciate its advantages; even among some critical professionals this feeling persists for the positive focus of a split image. You may even like single-lens reflexes but find yourself leaning to one that has a split image, despite the fact that it will be more obtrusive. Look at this Pentax microprism and think of the problem of focusing on faces. Remember how happy the split-image man was to be focusing on someone with glasses? How he'd tilt and twist his camera to find a line going in the vertical direction? Well, notice in the Pentax how easily you can focus on the highlight in an eye, on a tooth, an ear, or just a shadow; even hair gives precise focus. A sharp line will give you almost as positive a focus as the split image, but with the Pentax that line can be running in any direction.

Rapid Shooting

Some photographers say that certain rangefinder cameras can be shot faster than the single-lens ones for close, fast action or for candids. A few cameras do have this speed facility, as with rapid cocking devices, but it cannot be cited as sufficient reason for choice in candid work where the Pentax, for example, has the single lens reflex advantages in following,

ease of operation, ability to see expression at subtle angles, to relate expressions of two or more people to each other, and to see actual depth. In any event, I have shot 36 exposures with a Pentax in 36 seconds; the speed had to be a 1/125 to stop shake, my framing was not exactly precise, but I got fast pictures with single-lens advantages.

The Pentax shutter release has a smooth, "soft" movement, with a positive resistance when you have pressed down to take up the slack and are ready to catch the peak of some action. Despite its double function of tripping both the lens diaphragm and the shutter, it does both without any stiff interruption.

On some automatic reflexes these two actions of the release are quite sharply distinct and definite, requiring a heavy, double pressure of the finger. A smooth, soft release is crucial to catch peak action and to avoid camera movement.

Loading and unloading the Pentax are simple operations that can be performed in the hands without resting the camera. The back is hinged so that you need not stick it into a pocket while loading, or lay it down where it may get dust in it or be accidentally stepped on. The hinged back also allows reloading without removing the Pentax from a tripod.

Pentax prices

The story of virtues and versatility can't be left without the happy Pentax ending: prices. They start with the H-1a at $159.50. The SL sells for about $200.00. The Spotmatic is $299.50 with the f/1.4 lens, $259.50 with the f/1.8 lens. The Pentax Spotmatic f/1.4 comes in satin black finish for $10 extra. You can spend a great deal more for a fine reflex and get only trimmings for the difference; the Pentax will take as good, or better, pictures and perform as many diverse feats of photography with more ease of operation. A more expensive camera may bring you a single, unusual feature and then lack some basic advantage of the Pentax.

Camera cost isn't the end. No one buys cameras in this class without wanting to add lenses and at least some accessories. The Pentax is the heart of one of the most complete *systems* of photography, and the later costs of expanding your kit of tools should be considered. What you save on the initial camera alone can pay for two extra lenses—or even an extra camera.

Weighing the models

The three current models of the Pentax and their standard Super-Takumar lenses are the H–1a with 55mm f/2, the SL with 55mm f/1.8 (1/3 f-number faster) and the Spotmatic with 50mm f/1.4 (a full f-number faster than f/2).

The new SL, replacing the H–3v, is identical to the Spotmatic except that it lacks the internal meter system. The H–1a is identical to the H–3v but it lacks the 1/1000 shutter speed and the self-timer.

The Spotmatic not only has the integral meter but several other improvements discussed in Chapter III. Its superb 50mm f/1.4 lens is not something to pass up lightly, but you can buy a Spotmatic with the 55mm f/1.8 lens and save $40.

The SL model has all of the improvements of the Spotmatic (noted in Chapter III), but without the meter it is substantially lower in price.

Two for the price of one?

There is one single-lens reflex costing far more than the Pentax that seems to be more ruggedly—and more heavily—designed. This much ruggedness can be important to a pro carelessly jangling three cameras around his neck in crowds or climbing scaffolds—if he can stand the extra ten ounces apiece. My choice is to invest less than that difference in an extra Pentax body as a spare for safety and for added flexibility.

Many professionals have three or four Pentaxes. One extra camera body gives them these flexibilities: They can shoot color and black-and-white at the same time; they can have a lens of different focal length on each; they can be sure that one is always loaded and ready; if something happens to one, they can go on working with the other. Some keep an extra H–1a for dusty assignments, the beach, splashy salt water locations and risky spots.

The Takumar lenses

Pentax mounts are threaded (42mm) and will take many lenses other than Takumars; adapters are available for close-up work with some Leica and earlier Asahiflex lenses. Current Takumars are recommended, however, for many reasons. They incorporate the latest advances in formulas, coatings, materials, design and other factors that affect quality. Yet

they are good buys in the top quality range. Few other lenses compare for short length, light weight and smooth focusing. They are made for the Pentax and carry the Honeywell guarantee.

If you madly yearn for a telephoto and can't afford a good one, there are some for $75. They are not always sharp, nor very fast, may not have hard coatings or even the preset feature. You could easily be better off with a sharp Takumar of half the focal length, and get the same-size image by blowing up half of a fine-grain negative. Be wary of lenses that carry no guarantee and for which there is no servicing. Low-priced alloys can wear in the threads and throw off your focus. Check for inaccurate focus markings and loose elements. Shoot a wide variety of pictures during the ten-day trial period (or longer, if possible). Do you get a lens hood and leather case with the bargain lens?

Generally, it is wiser to stick to Takumars, and here are further reasons: In addition to providing very high quality at reasonable prices, Takumars are consistent from lens to lens; you are unlikely to get a bad one unless someone dropped it after it left Honeywell's hands. The Takumars cover the wide range from 17mm to 1000mm. Resolving power at extreme apertures is held to close tolerance. Certain Pentax accessories have been designed to fit one or more lenses, which means you need buy and carry fewer lenshoods and filters; a pair of good filters for a large lens can cost $50. Fifteen of the 27 Takumars take the same-size 49mm filters. Seventeen of them are fully automatic Super-Takumars.

Also, all Takumars are physically as consistent with each other as it is possible to make them. All the focusing and aperture rings turn in the same direction; infinity and smallest apertures are always on your left. Other lenses differ, and it can be disconcerting to put one on your camera and find yourself following a moving subject and by habit focusing in the wrong direction; in fact, such a lens will ruin the valuable automatic habit of always focusing in the right direction.

Takumars are high-speed, high-resolution lenses whose complicated formulas have been worked out on an electronic computer. Despite the latest manufacturing techniques, each lens requires hours of painstaking hand craftsmanship. After it has passed through Asahi's quality control and inspection, the Denver quality control center double-checks it against definitive standards with advanced optical and electronic

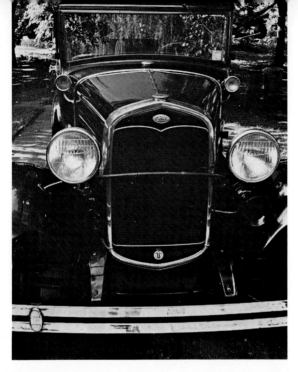

Wide angle distortion above stretches Model A Ford both toward and away from camera. Reverse effect of 200mm (right), from farther away, compresses car upon itself.

gear. Then Honeywell guarantees it against defects of materials or workmanship for 12 months after purchase.

Takumars of all lengths screw directly onto the camera without adapters. Leather cases for each are included in the price unlike most cheaper ones, and lens hoods are included with almost all of them.

Learning from lenses

The final beauty in single-lens Pentax viewing is the experience of learning to see through each new lens you get. Each focal length opens up a new world of creative possibilities, and the current Takumar series includes 27 lenses in sixteen focal lengths. You may have used a rangefinder wide angle, but if you have never looked *through* a wide angle lens at its actual broad, encompassing view and tremendous depth-of-field, you are in for a delight that will grow with

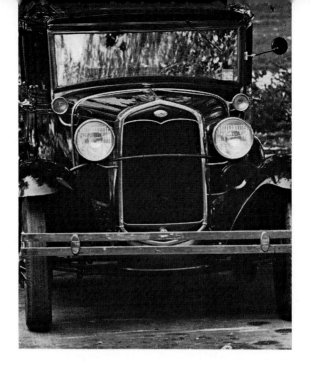

Note front of car in 35mm picture at left is larger than in 200mm above, but back of car is smaller; in 200mm picture, front of car is smaller but back is larger. Takumars, 35mm and 200mm.

use and experience. When you first shift from the standard 55mm to a 105mm lens, which tunnels in on distant subjects and isolates them from background and foreground, you realize that you have a new kind of selective eye at your disposal. Search over familiar landscapes with it, and you will find beautiful new details that your wide angle, deep-focus eyes have overlooked; aim it around at a crowd, and different, new and intimate views of people will pop out at you. You will learn new ways of seeing with each lens.

If there were only one piece of advice that thoughtful professionals could give to amateurs or beginners, it would be this: Get to know your camera and lenses so that all the mechanics of shooting become second nature, and your eye becomes educated to the seeing qualities peculiar to each lens. In the next chapter we consider the mechanics of the standard Pentaxes, a chapter is devoted to the Spotmatic and then we take up lenses.

The ABC's of the Pentax

THE FIRST IMPORTANT step in getting acquainted with your Pentax is the enjoyable one of playing with it before you load the film. This practice is more valuable if you make it realistic by pretending to take actual pictures, and begin forming definite and correct habits at the same time. The reason for habits is simply that you do miss pictures while fumbling with the controls, such as not knowing automatically in which direction to turn the focusing ring, or hesitating too long over any of the three basic steps detailed in this chapter.

Try to be patient with these "dry runs"; you are only doing what any good professional spends many hours at with a new camera. Shoot as many make-believe pictures as you can of varied situations, until you can almost operate the camera without looking at it. Your own reflexes should be developed to match the fast-operating ability of your reflex camera.

Set what you think are proper f-numbers and shutter speeds, focus on something, and begin tripping the shutter. You may be doing this with your Pentax for many years, so it is worth a little close attention.

Semi and automatic diaphragms

In 1963 the fully-automatic lenses were renamed Super-Takumars and now number seventeen lenses in focal lengths from 17mm to 300mm and the 70 – 150mm zoom.

On the old semi-automatics you set aperture, or f-number, then cock the lens lever for brightest viewing or exact focusing. The lens cannot be closed down again until the shutter is tripped. When you trip the shutter, the diaphragm closes to your pre-selected aperture to take the picture. It stays there after you cock the shutter for your next picture.

On Super-Takumars the lens lever has two positions and can be used to open the diaphragm or close it down. You

On black-body Pentax, the automatic lens lever (under letter X) now on eleven Super-Takumars. On A position, lens is wide open for bright view, sharp focusing; when shutter is tripped, lens closes to selected aperture and then opens again. On M, lens stays closed or shows depth of field.

can keep opening and closing it with an easy flick of your left index finger. Of course, when it is wide open for bright focusing or viewing (on A, or automatic), and you trip the shutter, it closes down to take the picture at your pre-selected aperture. But then it immediately returns to wide open for viewing your next picture. When the lever is on M (or Manual), the diaphragm remains at the selected aperture and you view at that opening.

The advantage is that with these lenses you can keep refocusing critically at widest aperture, or follow a subject in dim light, close down momentarily to check depth of sharpness, and switch back and forth as you please.

Holding it for sharpness

All exposures that you make at less than 1/125 second will benefit greatly by practice in holding the camera steady, and it does take practice to get sharp pictures at 1/30 or slower. I can manage 1/15 without support, but not reliably unless I can get one elbow on a solid surface. With both elbows firmly rested I can shoot a risky 1/8. By resting the camera itself firmly, 1/4 is possible. Some photographers claim they can hand-hold 1/4, but it's beyond me.

Even at medium speeds, a steady camera will improve sharpness. Always spread your feet comfortably for bracing. Hold elbows against your body. If you can find support, even at 1/60, use it: the elbow support may be a table, the back of

a chair or a shelf; you may lean your back, bottom, shoulder or camera against a wall or post. Photographer David Eisendrath once said, "Man is merely a two-legged tripod"; finding a third "leg" for support helps a lot.

Trigger technique

The "trigger" or shutter release must be squeezed with a firm but gentle action of the index finger and you should learn to hold your breath as you trip it. Most schools of thought recommend that you arch the index finger over the button, so that it absorbs shock like a cable release. I am experimenting with holding the index finger flat across the frame counter and rolling the tip of it gently over the button; the right thumb would do this when holding the camera vertically. The results of this experiment will hardly be earth-shaking, but I hope will not shake the camera either.

Now place your thumb on the cocking lever, next to your nose, and fire off a series of shots, thumbing the lever each time without taking your eye from the finder. I've found that in bright overhead light my thumb on the lever shades the viewing window and makes the image much clearer.

To be ready for peak action and alert shooting generally, you must learn to press the release button down somewhat before you shoot, to take up the slack in its travel. This is the point just before it first trips the diaphragm and then the shutter, and you will feel it.

The view from here to there

Elementary composition dictates that you be as ready to shoot vertically as horizontally, and switch from one position to the other automatically. In taking verticals, you have to decide which end of the camera is up: with the top of it to the right or left, the shutter button up left or down right. I find that with the shutter release down I can brace the Pentax better against my forehead and nose, recock more quickly, and my right arm becomes less fatigued than when reaching up and over the camera. Another person might have more difficulty holding the camera suspended in the left hand. The point is to find the best way for yourself and stick to it so that you won't hesitate and miss good vertical pictures.

Of course, you know that the cocking lever also advances the film, and you will note that it moves smoothly in

a short arc, snaps back and then locks until you trip the shutter. If you don't complete the stroke, you are prevented from tripping the shutter; push the lever again until it clicks. Get accustomed to doing this with a single stroke and immediately after each exposure. The cocked indicator on top of the camera turns red when you are ready, but the locked lever under your thumb tells you that without looking.

You soon get the feel of the lever so that when you reach the end of a roll you won't give a hard push that will pull the film out of its cassette.

Some earlier Pentaxes were built so that the reflex mirror rested in a slightly different position before and after cocking the shutter. It was therefore best always to cock before focusing. This is no longer necessary.

We now come to the three basic steps of all photography: focusing, aperture and shutter speed. It will still be found helpful to study them with an empty camera.

First step: focus

There's more to be said about focusing than anyone would care to read all at once, but after all, it is simplest in a single-lens reflex and brightest in the Pentax. For now, we'll consider the mechanics and a few basic tips.

The standard technique is to focus past the sharpest point, come back into unsharpness, and go back and forth in shorter passes until you are right on the dot. With practice you'll often need to make only one pass and a slight return.

Your main subject is not always the thing you should focus on. If you want to include something in either foreground or background you must use the depth-of-field scale to pick a range that includes the subject and the other distance. You needn't tape-measure the near and far distances, but can use your camera as a rangefinder; at widest aperture, focus first on the nearest and then the farthest distances and read them off the distance or foot scale. Set these against your proper apertures on the depth scale. If they won't embrace the measured distances, close down further and use a slower speed. If they still won't fit, you'll have to back away from your subject to get greater depth-of-field.

For moving subjects, it is sometimes easier to move back and forth with them rather than to continually refocus. This also helps to keep your frame filled.

You'll notice that you can focus in any part of the view-

ing frame, but that the round spot in the center, a micro-prism, gives you an especially sharp focus on a narrow plane. It tells you only that you are exactly focused on a hairline; the rest of the frame shows the depth of sharpness at any particular aperture.

If you wear eyeglasses, Honeywell provides an accessory eyepiece that takes a prescription lens. See Chapter XI for details.

Second step: aperture, or f-number

The aperture or lens opening is that diaphragm setting which controls the amount of light allowed through a lens. Each numbered stop from the widest (lowest number) to the smallest (highest number) allows half as much light to enter as the previous stop; in reverse, each wider opening allows twice as much light through. You select aperture with one of the two ribbed rings on each lens. Note that the ring clicks positively into place at each stop and most half-stops; this prevents the ring from being accidentally turned while you are shooting and also allows you to change aperture without taking your eye from the viewfinder.

Widest lens openings are not always a full f-number faster than the next marked position. On Pentaxes, f/2.2 is about two-thirds of a lens opening larger than f/2.8, while f/2 is a full opening larger; the f/1.8 is about one-third of a lens opening larger than f/2. The full f-numbers are: f/1.4, 2, 2.8, 4, 5.6, 8, 11, 16, 22.

Look into your lens and turn the aperture ring to vari-ous stops and you will see how the diaphragm works (on cur-rent models set lens lever on M). Now set the ring for some smaller aperture and press the shutter release. The diaphragm closes to your preselected aperture; then you'll hear the shut-ter click. On the new fully automatic lenses, the diaphragm will automatically open again to full aperture if it is set on A. On other models and with earlier Auto-Takumar lenses, it will remain at its preset stop until you press the lens lever for bright focusing.

Now look through the finder while you close the ring down to successively smaller apertures. As the image darkens slightly you'll see more and more zones of depth come into sharpness. Examine subjects closer and farther away and watch how the depth-of-field varies, becoming shallower as you focus closer, deeper as you focus farther away. Let's

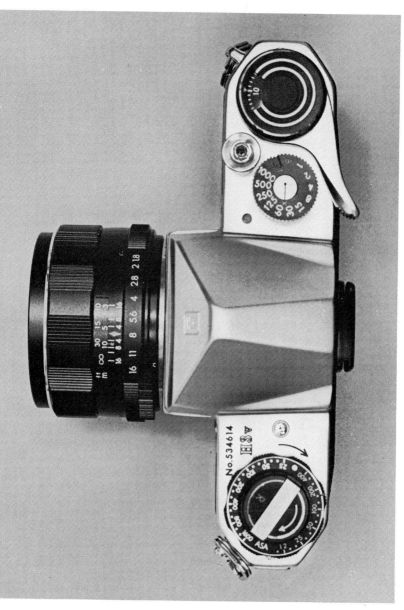

All settings and controls are seen from top of Pentax, on H–1a as well as this H–3v. Note clear markings. Camera reproduced actual size.

Holding camera horizontally. The Pentax here took its own picture in a mirror. Negative was reversed in printing.

take some examples of the aperture's double function of controlling light, which affects exposure, and of determining the zone of depth.

Look down at the foot-distance scale on your lens and set it so that 15 feet is opposite the red dot marker. Behind the movable foot scale is a fixed scale, repeating the f-numbers on both right and left, with lines running up to the foot-markings. It is your depth-of-field scale. Notice that at a little past 15 feet the infinity symbol (∞) appears opposite the f/16 mark on the left, while ten feet appears opposite the f/16 mark on right. This shows that if you have set the aperture at f/16 and focus at 15 feet, everything in your picture will be acceptably sharp from ten feet to infinity. If your lens closes down to f/22, you can have everything in focus from 7.1 feet to infinity. A depth-of-field table for 55mm Takumars is given at the end of this book.

If you want less to be in acceptable sharpness, you must choose a larger lens opening. If you choose a larger opening, you will have less depth-of-field. You've noticed, however, that the closer the subject on which you focus, the less deep the field of sharp focus. There is, roughly speaking, twice as deep a zone of sharpness behind the plane focused upon as there is in front of it, although at close distances these sharp zones become equal.

The depth scale on the lens can also save you from "throwing away" valuable depth. Look at something about 30 feet away in light that would require a stop of f/16. When you are focused directly on it, the infinity mark is opposite f/11. So, you can turn your infinity setting to f/16 and thus

gain several feet of sharpness on the foreground side of your subject and still be acceptably sharp to infinity. Or, if you are interested in more sharpness in the foreground and not at infinity, you can push your 30-foot setting up to f/16, so that everything behind it will go slowly out of acceptable sharpness, and you will be quite sharp from about eight feet to 30 feet. (These distances are for a 55mm lens; you get greater depths with a 28mm or 35mm lens, less with longer lenses.)

The extremes of your depth-of-field, however, will not be as *critically* sharp as the plane on which you are focused; they will be *acceptably* sharp. The falling off is gradual in both directions. If your picture calls for utmost sharpness at one plane, you should focus on it instead of using depth-of-field.

Handy as this depth scale is, it needn't be consulted for most pictures. Looking through the taking lens in the finder of the Pentax is where you make the creative decision as to how great or shallow a depth you want to be sharp. But the depth scale is easy to use in many other ways. When you are outdoors in bright light you can set a broad distance range without focusing at all. The scale is convenient, too, when you are using flash and have no way of visually focusing at the taking aperture.

This depth business, by the way, does not mean that the farther you close down a lens the sharper your pictures will be. Quite the contrary. It confuses many people who think they will get sharper pictures at f/22. Depth-of-field sharpness has little to do with the inherent sharpness, or resolving power, of any lens. All lenses are inherently sharpest at some middle aperture and fall off slowly as they approach lowest and highest apertures. For critically sharpest pictures, stay between f/4 and f/11. If you have an f/5 lens, of course, greater sharpness will result from closing *it* down a stop or

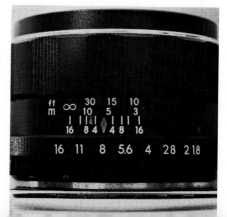

Clear lens markings: top, distance scale, then depth-of-field scale and, bottom, aperture ring. On 55mm f/1.8 lens. The f/1.4 and f/2 lenses are similar.

two. When you close down to f/22, it is to achieve greater apparent sharpness over a large area in depth—really using the lens at a less efficient aperture to achieve this effect.

Third step: shutter speed

The foolproof Pentax shutter speed dial may be turned in either direction and can be set either before or after cocking the shutter. It has Time (T), Bulb (B), 1 second, 1/2 second, 1/4, 1/8, 1/15, 1/30, 1/50 (a red X), 1/60, 1/125, 1/250, 1/500, and on the H–3v and Spotmatic 1/1000.

On the dial, the numbers 2, 4, 8, refer to fractions of a second: 1/2, 1/4, 1/8. If your light meter or exposure table gives slightly different speeds, such as 1/5, 1/10 and 1/25, you can safely use the nearest Pentax speed without noticeably affecting exposure. The red X marking is the maximum speed for electronic flash; it is 1/50 second (1/60 on the Spotmatic) and can be used as such without flash, too.

Pull out the slide latch on the end of your camera and open the back. Trip the shutter release for a variety of speeds and study how the focal plane shutter works. Note that with the dial set on Time, the shutter stays open. To close it, turn the dial one notch in either direction. The Spotmatic does not have the Time setting.

Loading up

Hold the camera with the hinged back toward your body. Pull out the rewind knob, top right. Drop a 35mm cassette into this chamber and push back the rewind knob. Pull out the film leader and insert it into one of the four slits in the take-up spool in the opposite chamber. If a slit is not in proper place, you can turn the take-up spool with your finger.

Now trip the shutter and push the cocking lever to advance the film until both sprockets have engaged the holes on each side of the film. If you have pulled out too much leader, turn it back into the cassette with the rewind lever, or advance the film a bit farther onto the take-up spool. The work is done by the sprockets, while the spool, with a slippage gear, tries to advance at a faster rate to take up any slack.

Close the back and lock it. The first two exposures, or frames, have been spoiled by light. Trip the shutter and advance the film twice to get unexposed film into place.

To load: advance film until holes engage both sprockets, then close back.

The automatic counter will now be at zero, advancing to 1 when you cock the camera again for your first picture. Set your film-type reminder dial. With these set you always know how much film is left on a roll and what kind of film it is. The counter enables you to remove a roll with a few exposures on it, use an altogether different film in the camera, and then to put the first roll back. Shoot "blanks" at high shutter speed with the lens cap on until you pass the exposed frames.

Notice that as you advance the film, the rewind knob turns. This is your check that the film is advancing properly while you shoot, and that it has not pulled out of the cassette at the end of a roll. The rewind knob is also used to check whether the camera is loaded; without pressing the rewind button, turn the knob a few times in the arrow direction—if there is film in the camera, you will feel it tighten up inside its cassette.

Unloading

After you've used up a 20- or 36-exposure roll the cocking lever will refuse to advance. The entire strip of film is now wound around the take-up spool and if the back is opened it will be exposed and ruined. To unload, you must rewind the film into its cassette.

Hold the camera with its back up and your left thumb on the little rewind button (marked R) on the bottom of the camera. Lift the rapid rewind handle from its knob (also marked R) and crank the film back into its cassette. Wind in the arrow direction only. Unless you are in an unavoidable hurry, wind slowly and evenly; under dry climatic conditions

fast rewinding may generate static electricity that can leave tiny, lightning-like streaks in your film. Also, you might tear the film. You should keep a good grip on the rewind crank; if it slips loose it will spring back several turns.

As the end of the film slips out of the spool you will feel the tension suddenly lessen. Ordinarily, you can wind this end right into the cassette. However, if you wish to re-use a partly exposed roll you'll have to stop as soon as the tension ceases so that some leader will still protrude.

Open the back, pull out the rewind knob and remove the cassette. It comes out easiest if you turn the camera over and drop the cassette into the palm of your hand.

There's a lot more to Pentax photography, but you are now ready to take pictures. You know all the necessary mechanics, except for a few warnings.

Cautionary notes

If you wipe your lens clean frequently and keep it nice and shiny, sooner or later you will have flat, muddy pictures. This is a common malpractice. Marty Forscher, New York's outstanding professional camera repair man, says that even his sophisticated customers are frequently guilty of this practice. Lens glass is soft, and the surface coatings that prevent flare and increase speed must be thin. *Wiping* dust, even with lens tissue or old laundered linen, is the same as using an abrasive; invisible microscopic scratches will degrade the lens. Oddly, a lens can carry a fair amount of dust without affecting your pictures. The only thing for dust, beside restraint, is a full sable brush, kept clean, or a regular lens brush—cleaned before using.

Fingerprints and smudges are far more serious. A little acid perspiration, left on the lens, can slowly etch a microscopic flaw in its surface. This can be worse than dust, even worse than a sharp nick in the glass. To remove such spots before they do damage, first carefully brush away every speck of dust. Then, with a soft, clean piece of lintless cloth, or undirtied lens tissue, lightly wipe away the spot. If it resists, breathe on it gently and wipe again, or resort to lens cleaning fluid—sparingly, a few drops on the tissue.

The eyepiece of your Pentax is harder glass and can be wiped with a clean handkerchief.

Lens caps keep off dust, fingerprints, nicks, humidity and also smog, cigarette smoke and other modern ingredients

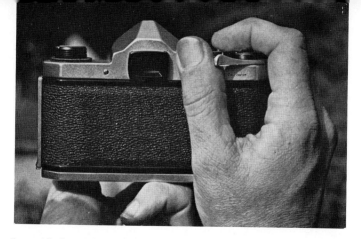

For quick shooting, grasp focusing ring with left index finger and thumb while supporting camera with remaining fingers; the right thumb rests on the cocking lever.

of air. Use rear lens caps religiously when lenses are off the camera; Honeywell provides both caps with each lens. The rear diaphragm pin on Super-Takumars must be carefully protected. Special care is needed to protect the protruding rear element of the f/1.4 lens on the Spotmatic.

The inside of the back of your camera body should be dusted occasionally with a brush or lintless cloth to remove the dust that gets in despite all precautions. The Pentax is designed so that the emulsion side of the film does not go over rollers or touch any camera surface; most scratches seem to come from dust on the lips of the cassette. But the back of the film does have to be held absolutely flat by the pressure plate in the hinged back, and there dust can scratch it, but less seriously. Never touch this plate with your fingers, and beware of jarring it out of its precise alignment.

Keep your camera in its case, a box or a plastic bag, away from dust, and in as dry a place and at as even a temperature as possible. If you are not likely to use the camera for several weeks (Honeywell says months), trip the shutter and close the lens diaphragm down to take pressure off the spring mechanisms.

The reflex mirror inside the camera body is another thing to leave alone. It is front-silvered and should never be touched by the fingers, or cleaned by wiping; use a brush if it gets so dusty that you can't stand it. Beware of blowing dust farther into the mechanisms and up into the reflex prisms.

27

The shutter curtains also should not be touched. And never, never oil a camera! After years of use, or misuse, the high speeds of any camera are likely to become inaccurate; an authorized Pentax repair man can lubricate the mechanism easily and properly, or any Honeywell Photo Products dealer can return it to the factory.

In warm weather never leave the camera or film in the hot glove compartment of a car or on the rear window shelf. Professionals have learned always to keep cameras in the (shaded) trunk of a car and to leave no evidence of photography, like used film boxes, in sight within the car. These tell-tale signs invite thieves. Camera floater insurance, by the way, is relatively cheap.

The longer the lens carried on a camera, the greater the danger that a slight jar or knock will damage camera or lens. The considerable leverage on the threads and camera housing can knock them out of alignment more easily.

Getting trigger happy?

The next chapter discusses the Spotmatic and then two others are devoted to lenses. If you are anxious to try out your Pentax now, with perhaps only one or two lenses in your kit, go right ahead. Chapters VI through VIII suggest a number of picture subjects that are readily available and that demonstrate the versatility of your camera.

It is usually recommended to 35mm beginners that they start with a black-and-white film of medium speed, such as Kodak Plus X Pan. It allows much more room for exposure error than color, is less expensive, and permits much wider trial and experiment with your new camera than either high speed black-and-white or any kind of color film. Plus X Pan has an ASA speed of 125 and with proper development yields superb prints of barely detectable grain in an 11 x 14 size.

The Spotmatic

The Honeywell Spotmatic unquestionably belongs in the Pentax family. It has the same look, handles with the same ease, and in spite of its new features, finer machining, and more rugged construction, continues the Pentax tradition of remarkably light weight and compact design. Yet in many ways, some hidden, the Spotmatic is a new animal rather than a slight mutation from earlier Pentaxes.

Its chief feature, of course, is the integral meter that measures the amount of light coming through the lens. Its two sensitive cadmium sulfide sensors read the exact average of the light falling on the ground glass, which is the light that will fall on the film when the shutter is released. A needle in the viewfinder window indicates when correct settings have been made or else shows that the settings chosen would result in over- or under-exposure.

This through-the-lens metering is an advance in photography comparable to through-the-lens viewing in simplifying and speeding up the process of taking a picture. It makes possible much more precise exposure under widely different and rapidly changing light conditions.

The Spotmatic camera itself becomes your exposure meter, and taking a reading and taking a picture become part of the same action. You do not need to take a separate reading and then transfer it to the settings on your camera; setting of apertures and shutter speeds on the camera operate the meter. When the needle of the meter is centered by a combination of these, you are ready to shoot.

If you wish to expose for special effects, or for a selected area of your subject, you can do so, using the meter's correct average reading as a starting point.

This arrangement gives you constant control over exposure while you are taking pictures. In fact, with the Spot-

matic everything important to a picture is now seen in the viewfinder and can be controlled without taking your eye from the finder. To the acts of focusing, composing and judging depth of field has been added the ability to find correct exposures and change settings immediately as you shoot.

This simple but revolutionary advance makes exposure almost infallible, even under rapidly shifting light conditions. It gives you a corrected reading for each small change in camera viewpoint, and makes correct exposure possible in many new kinds of difficult and fast-moving situations. Yet the meter controls nothing; it merely tells you when you have picked the right settings or whether you need more or less exposure.

Let's look at a few other Spotmatic advances and differences before taking up its operation in use.

The new f/1.4 Super Takumar

The new 50mm f/1.4 Super-Takumar lens that comes with the $299.50 Spotmatic is a full f-number faster than an f/2 lens. Its design represents a further advance in combining high resolution with high optical contrast, a concept that Honeywell refers to as "image fidelity." Its pictures thus not only have an inherent sharpness, or resolving power, but this effect is enhanced by a "snap" and brilliance in the contrast of adjacent tones in the photograph. It is an eight-element lens. For a real bargain, you can also get the Spotmatic with the truly fine 55mm Super-Takumar f/1.8 lens for $259.50.

Other Spotmatic features

The shutter system on the Spotmatic has been redesigned for greater accuracy and reliability; a new eccentric cam maintains accuracy even at sub-zero temperatures. The shutter curtain is made of a more rugged rubberized silk. Electronic flash is synchronized up to 1/60 second instead of 1/50. The mirror action is faster but new dampers absorb shock and prevent vibration. Internal machining is to closer tolerances. The lens mounting plate is sturdier. The film advance lever moves in a shorter arc or "throw" (160° compared to 180° on other Pentaxes) and it can be advanced by several short strokes as well as one long one. It can be moved to a slightly forward "ready" position.

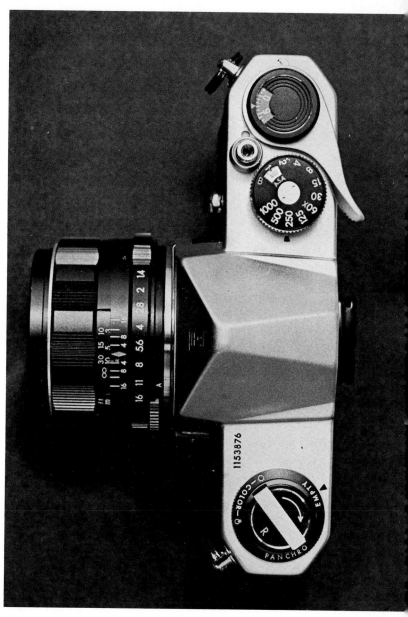

Spotmatic Pentax in "life" size. All settings are seen from top. This view
can be compared with a similar one of the Pentax H–3v shown on page 21.

31

Despite these improvements and the internal meter, the Spotmatic weighs only two ounces more than the H–3v and more than half of the increase is in the new, fast lens. The entire camera weighs 2½ ounces less than the H–3v with its accessory meter attached.

The 20 different film speeds governing the battery-operated meter range from ASA 20 to 1600. To operate the Spotmatic you set the ASA speed of the film you are using in an indexed window on the shutter speed dial. This automatically calibrates the meter for all exposure settings with that film. The meter is electrically coupled to this setting and to shutter speeds and, of course, responds to each change of aperture. The meter is turned off and on by means of a switch on the lens mount, under your left index finger when you are taking pictures. If the switch is left on as you photograph, tripping the shutter automatically turns it off.

A needle inside the viewfinder window is centered when shutter speed and aperture are correct. When the shutter speeds are beyond the range of the meter, the needle drops down abruptly and a small window beside the shutter speed dial turns red.

Using the Spotmatic

Opening the back of the Spotmatic for loading is a little different than on other Pentaxes. Instead of having a separate slide latch, the rewind lever is lifted and the back pops open. After you load, remember to set the ASA dial for the speed of film you are using since this calibrates the meter. It also serves to remind you of the speed of the film in the camera. A separate dial on the rewind knob can be set for the type of film. The frame counter sets automatically.

When you are ready to take a picture you focus and compose first and then press up on the meter switch. This turns the meter on and also closes the lens diaphragm to any pre-selected aperture. If you have the right combination of shutter speed and aperture, the needle, on the right side of the finder just beside the picture area, will center itself. When the switch is on, the lens operates manually so that as you change apertures the needle will rise and fall. If the needle is above center, in the area marked with a plus sign, your picture would be overexposed; if the needle rests below center, marked minus, you would be underexposed.

To center the needle for correct exposure you will usually change aperture. This is done with the left hand, while the right index finger rests on the shutter button. You can also change shutter speeds to get more or less exposure. In either case you needn't take your eye from the viewfinder.

We'll come back presently to some tips, warnings, and technical matters concerning the Spotmatic. Let's first try to see something of what it does for us in picture taking.

With the Spotmatic you always know that you are measuring the amount of light coming through the lens and therefore the light that will fall on the film. Remember that it is the exact *average* coming from the scene you are photographing (more technically, the "integrated mean brightness"). No matter what focal length of lens you use, the subject area it covers becomes the acceptance angle of the Spotmatic meter. The meter reads what the lens "sees." No matter what filter, extension tube, bellows or other attachment you use, the meter measures the light that will reach the film. No more filter factors, no more exposure calculations for extensions. Exposures through a microscope are usually made by trial and error, but the Spotmatic gives precise readings to fairly low light levels.

In photographing ultra close-ups it is usually impossible to get a precise reading with a conventional meter. The subject is too small. But the Spotmatic reads the exact area framed, even if it is a postage stamp or only the head of a pin.

The Spotmatic gives the photographer the flexibility and speed of instant exposure control without taking any of the control away from him. Without the constant monitoring of such a meter in the viewfinder we have all had problems where light intensity keeps shifting (under intermittent clouds, in theaters); where our subjects move into or out of brighter and darker areas (sports events, picnics in spotty sun and shade); where there is sun or other bright light in one direction and shadows in the other; and also, in cases where a series of brighter and darker subjects present themselves one after the other.

In such changing situations, stopping to take a reading with a separate meter often means losing the picture. Also, a conventional meter's angle of view usually takes in a larger or smaller area than our camera lens.

Subjects are often inaccessible for a meter reading. If you are photographing from a balcony or a grandstand, up-

stairs in a building, the side of a mountain, across a stream or river or from a seat in a theater, it may be difficult or quite inconvenient to read the light on your subject. The Spotmatic usually solves these problems.

When I first got my Spotmatic I found myself in an airplane passing through dramatic clouds that ranged from sunlit white to threatening dark. Holding the camera against the window I watched its meter needle riding up and down. By aiming a little ahead, my left hand shifting the aperture ring, I was able to center the needle and photograph each cloud as the plane came alongside it. About 20 widely varying exposures produced negatives of uniform density. The point is not merely that you can determine correct exposures while shooting from speeding planes, trains and cars, but that the system does work quickly under rapidly changing light.

Some Spotmatic tips

While the Spotmatic meter invariably gives you the best exposure for the *averaged* brightness of a scene, there are interesting kinds of pictures where this is just the point of departure. For example, you will sometimes want to expose for either the bright or dark areas of a subject while you let the rest of the area become underexposed or overexposed (you may be more interested in either bright faces of people or in showing their dark clothes).

A typical example is a picture of someone against the sky or a portrait against a large, bright window. The meter will average a lot of bright area with a small amount of shaded face, and such a picture might turn out to be a silhouette. You have to make a choice; if you want detail in the face you will have to allow more exposure (move in close to the face for your reading, or read your own hand). With more exposure, the sky or window will be overexposed. Both the silhouette and the overexposed background can be good pictures, but they are different. Where the brightness range between face and background is not too great a compromise exposure halfway between the two can get both elements into the picture.

In everyday, practical use it usually turns out that you can just aim the Spotmatic at the part of the scene that you want to expose for, get the proper settings, and then frame the exact shot you want. An example might be a group of

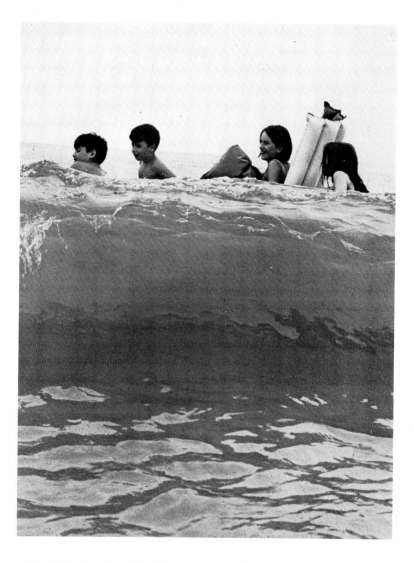

The 105mm lens brought children close to crest of wave as well as to photographer, who kept feet dry. ASA 200, 1/1000 at f/11.

people in backlighted sun. You can simply aim the camera down slightly to include only the shaded people, get your settings and then raise the camera for the picture.

If you like to expose carefully you will discover that the Spotmatic meter is so sensitive that you will often find yourself adjusting the aperture ring to positions between the half-stop click settings. Such quarter-stop precision gets pretty academic, even for exacting color exposures, but it is nice to be able to get it when you want it.

The Honeywell direction booklet that comes with each Spotmatic advises that you focus first and then take your meter reading from the in-focus image. This is apparently because in a few picture situations the proportion of bright and dark objects, some in the foreground and some in the background, changes with focusing. In other words, if you take a reading of something close by while focused at infinity and then refocus on the nearby object, the object will become a little larger in the frame and its brightness may change the meter reading. You can make a long search for such an arrangement of subject matter that would require more than a quarter-stop adjustment.

On Spotmatics available until mid-1966, when the meter was turned off the needle rested in the center position, which also indicates correct exposure. It was possible for a photographer to mistake this for an indication of proper exposure when actually he had not turned on the meter. I did not find this much of a problem in practice, but it has been changed so that the needle has a special OFF position slightly below center. One usually knows when he has turned the meter on. A problem that remains is remembering to turn the meter off again after preparing to take a picture and then deciding not to.

Checking the battery

The Spotmatic is powered by a tiny battery of hearing-aid size in a receptacle in the bottom of the camera. It should not need replacement more often than once in a year or two in normal use. A replacement battery is provided on the inside of the top of the case, hidden in a little pocket. Use only the special type of battery approved for the Spotmatic: a Mallory RM400R, a Burgess HG400N or an Eveready E400N.

Testing the battery is simple. Move the shutter speed

dial to a high or low speed until the little indicator window beside the dial turns red. This shows that you are set beyond the range of the meter. Then turn on the meter switch. If the needle drops abruptly, the battery is live. If it sinks slowly, the battery has lost its capacity and should be replaced.

A few other things need to be known about the Spotmatic in relation to other Pentaxes.

You will note that the fast 50mm f/1.4 lens has a protruding rear element. Because of this the lens cannot be used on all earlier Pentaxes; only those H–3v and H–1a models made since 1964, with an orange "R" marked on the rewind knob, will accept this lens. Earlier models, with a green "R," will allow the mirror to hit the rear element and probably damage it. The mirrors on earlier Pentaxes can be modified by Honeywell to take the new lens. All Takumar lenses can be used on the Spotmatic.

The 50mm f/1.4 lens accepts the same 49mm filters that fit fourteen other Takumars.

To accommodate the meter system on the Spotmatic, the self-timer was moved and is now operated by a lever located on the front of the camera. It provides a shutter delay of five to 13 seconds. Unlike other Pentax self-timers, it is actuated by its own release button, under the lever, instead of by the shutter-release button. If you trip the latter, the shutter will operate without the delay.

In 1969 Honeywell announced an SL model Pentax based on the design and construction of the Spotmatic but without the through-the-lens meter system. The SL comes with the f/1.8 Super-Takumar or without lens and is about the same price as the H–3v, which has been discontinued.

The Shorter Lenses:
17mm to 150mm

THE 55MM LENS on the Pentax presents an image approximately as large as your eye sees it. A 105mm lens gives an image roughly twice as large, and three times as large as a 35mm. You can use long and telephoto lenses as low-power telescopes on your Pentax and see more through them than with the naked eye.

Photographers once thought mainly of wide angle and telescopic lenses in such terms of image size. If you couldn't get far enough from a subject, you used a wide angle; if you couldn't get near enough, a telephoto was called for. Now we've become more aware that each lens length has its own more creative possibilities.

Besides image size, the focal length of a lens governs two other things: the appearance of perspective, and depth-of-field. These latter two can have a radical effect on the character of a picture.

Getting most out of a wide angle

Let's see what you can do with a 28mm or 35mm wide angle and discuss the Takumars in these focal lengths. I believe that the 35mm is the best choice for one's second lens; many good photographers seem to agree, and I've found that I use it for more pictures than any other lens. There is a trend toward emphasizing longer lenses, but that should not lead us to overlook the versatile wide angle.

Obviously, the 35mm wide angle takes in a broad view; actually, a 63° angle (measured diagonally in the frame). This lets you "get more into the picture," but it also allows you to relate a small foreground object or area to its large background "canvas."

This is the next quality you will notice in a wide angle lens: It allows you, for instance, to get the bride large in the foreground aisle while including the sweep of church and spectators; or to shoot a distant landscape yet include in the

foreground some figures, plants, a frame of trees or part of a nearby building—so that in looking at your print the eye travels back and forth, from the near to the far, and the picture has depth and interest. The 35mm is the lens for the kind of portrait that relates an artist to a display of his works; a man to his office or habitat; or a close-up flower to its woodland setting.

Such pictures are made possible, also, by the great depth-of-field in wide angle lenses. With a 35mm at $f/16$ you are sharp from just past four feet to infinity. At $f/8$ you are sharp from eight feet to infinity.

In fact, it is difficult to get anything out of focus in a 35mm picture, unless it is very close and your lens is wide open. It is sometimes hard to focus a wide angle lens in a reflex viewer because almost everything is sharp. In well-lighted situations it is easiest to guess your distance range and check it on the depth-of-field scale of the lens. Even at $f/4$ you will be acceptably sharp from ten feet to 30 feet.

This great depth of wide angles can be traded for speed: instead of taking a picture at $f/16$ and 1/60 second, you can open up two apertures to $f/8$, increase your speed two times to 1/250, and get the same exposure. Using 1/1000 at $f/4$ would still give the same exposure.

There are subtler advantages to wide angle shooting. Groups of people can be better "covered"—think of such examples as a children's party, men conferring or huddling, spectators, a party on the beach or in a home. With a longer lens you must back off from such groups, and then they are likely to block each other from your view. If you want to shift your angle, you must move over a long arc; if you want to look down on them a bit, you need a ladder; if you see a low-angle shot, the ground gets in the way.

However, by circling close to the same subjects with a wide angle lens you can maneuver more quickly and in a smaller radius; each foot that you move your camera up, down or to the side gives you a much more altered angle of view. You can close in quickly on two interesting faces, yet by backing up just a few feet you can include the entire group. If anyone moves in front of you, or blocks your picture with the back of his head, you can take one sidestep and recover your target.

Furthermore, the perspective of the wide angle view sees between things better, looks over or under obstacles to get a broader view, and opens up tight situations. Let's take

that small group. Two people facing you offer a good shot, but their faces are partly blocked by two other heads or shoulders. With a longer lens you back up, and the faces are further blocked; with a 35mm lens you move in closer, poke your camera close between the two blocking persons, and its wide view takes in both the faces you want. Or, you use the blocking people to frame your shot. This works the same way with doorways, looking over fences, between two trees and all kinds of obstacles. You get close to them and see beyond into a broad view of your subject.

Wide angle tricks

However, for flattering portraits one should not get too close to people with wide angle lenses. As an object is brought closer to them it appears to increase in size more rapidly than when seen with a 55mm. This is why at short distances a nose, closer to the lens than the rest of the face, will appear abnormally large. You can use this peculiarity in tricky but cliché pictures: the shot of a large hand outstretched toward the camera, its owner seeming to shrink away in the distance; a three-quarter view of your car with its front looming up at you dramatically (car brochures, of course, exaggerate interior roominess with wide angle photographs); or for close-up portraits of your enemies.

You can violate the "ban" on wide angle portraits by simply backing up and using only two-thirds of the frame.

Another caution in using wide angle lenses: If you tilt the camera sharply upward or downward on a scene where there are straight vertical lines near the sides of your picture, these lines may diverge disturbingly out of your frame. This cannot be a hard and fast rule; some pictures are worth the penalty, and it isn't always disturbing. In candid photographs your dominant people in the foreground may make diverging lines in the background of little importance. In some shots, an extreme tilt is better than a slight one.

Oddly, the convergence and divergence that you get from tilting a wide angle applies only to upward and downward tilt; sideways tilt has little effect, because the eye accepts it, and there is merely the appearance of exaggerated perspective. This is why the wide angle, held level, is so excellent for many kinds of architectural photography, interior room shots, factory pictures and cityscapes. It lets you get close to large structures yet hold distant sections sharp.

Wide angle lenses are particularly subject to reflection of stray light rays on the broad, convex surface that protrudes from the barrel. If you view carefully, you will have the single-lens reflex advantage of seeing such reflections in your finder and be able to avoid them. Always use the lens shade designed for your particular wide angle lens since a deeper shade may cut the corners of your pictures.

Two 35mm Super-Takumar lenses

Choosing between the two fully-automatic 35mm Pentax lenses presents some clear-cut alternatives. The slower lens is small, very lightweight, moderate in its f/3.5 speed, and moderate in its price. The f/2 Super-Takumar lens is extremely fast, but costs $85 more than the f/3.5.

1. 35MM SUPER-TAKUMAR f/2, with eight elements. Minimum aperture, f/16. Minimum focusing distance, 1.5 feet. Weight, 8.5 ounces. (Replaces 14-ounce model.)

2. 35MM SUPER-TAKUMAR f/3.5, with five elements. Minimum aperture, f/16. Minimum focusing distance, 1.5 feet. Weight, 5 ounces.

If you do not shoot often in dim light where bright viewing is important, and depend more on the depth of field of a wide angle lens, rather than focus on one critical plane, the slower lens will be a fine performer.

In such a choice, though, there is one thing to know about fast versus slower lenses. Generally, sharpness of any lens improves markedly when you close down a stop or two from the widest aperture. Thus an f/2 closed down to f/3.5 would be sharper than an f/3.5 lens would be wide open.

Wider-angle Super-Takumars

The 24mm and 28mm Pentax lenses extend the characteristics of the 35mm lens to dramatically wider angles. They cover areas twice as large as the 50mm and 55mm lenses and permit pictures in cramped locations. They provide tremendous depth: with the 28mm lens at f/16 your photographs are acceptably sharp from 30 inches to infinity.

24MM SUPER-TAKUMAR f/3.5. Nine elements. Minimum focusing distance, 9.6 inches. Angle of view, 84°. 8.7 oz.

28MM SUPER-TAKUMAR f/3.5. Seven elements. Minimum focusing distance, 15 inches. Angle of view, 75°. 7.3 oz.

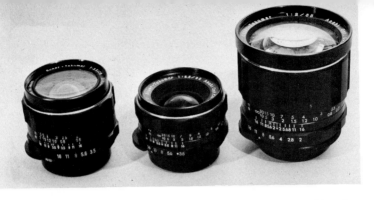

Automatic wide-angle lenses: the 28mm f/3.5 (left) and two 35mm's —
the small f/3.5 (center) and the fast f/2 (right). A 17mm Super-Takumar
Fisheye f/4 is an extreme wide-angle lens.

17MM SUPER-TAKUMAR f/4 is a remarkable Fisheye that
covers a 160° angle of view with full mirror action. It is
automatic, has 11 elements and three built-in filters, yet
weighs only 8 ounces. Minimum aperture, f/22. Its closest
focusing distance (about 8 inches) is hard to find and its
angle of view is too wide for a lens hood.

The 85mm versus the 105mm versus the 135mm

If you take most of your pictures indoors, at moderate
distances, and if you seldom want to pick out individual
figures from quite distant scenes, photograph uncooperative
birds, or cover races from the back seats, then possibly the
85mm is the best next choice after the 55mm and the 35mm.
It gives a larger image with little penalty in loss of depth. It
allows you to stay near enough to small groups and indi-
viduals to know what they are doing, to swing around to
get different angles, and to direct your subjects if you wish. It
is an excellent portrait lens and is extremely fast.

85MM SUPER-TAKUMAR f/1.9. Five elements. Minimum
focusing distance, 2.75 ft. Angle of view, 29°. Weight, 12.3 oz.

The 105mm reach

With the 105mm focal length you have a moderate tele-
photo lens. It gives you an image almost twice the size of a
55mm lens, and its narrow "corridor" of view, 23°, allows

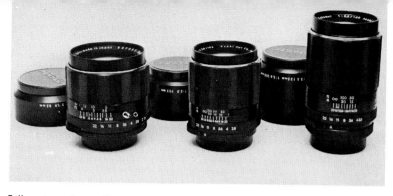

Fully-automatic medium telephotos: Super-Takumars, 85mm f/1.9, 105mm f/2.8 and 135mm f/3.5. These come with their own special lens hoods. Not shown: Supers 135mm f/2.5 and 150mm f/4.

you to be very selective of backgrounds. It gives you the best range of depths-of-field from wide open to closed down; you thus have a broad choice of shallow depth at f/2.8 to considerable depth at f/22. For example, when focusing on a person 20 feet away at f/2.8 you will have less than two feet of depth, but if you close down to f/22 you will gain 15 feet of depth to work with. You must keep shallow depth in mind as a limitation with long lenses, but using it creatively is what makes many telephoto pictures unique.

The 105mm is also excellent for portraits, especially if if you want "tight" heads, or a head and shoulders, and don't want to crowd right in on your subject. At six feet, a person's head fills your frame tightly; at 20 feet, you can just include a standing figure or a stretched-out bathing beauty.

Not only does this lens give you high speed in a long lens, wonderful for low light interior shots, nature and sports, but it is small, short in length, lightweight for handy carrying.

The 105mm lens begins to radically change your view of things, educating your eye to pick out significant details, teaching you to "crop in" closely on your subjects for intimate and uncluttered pictures of essentials. You'll find too that it is wonderful for keeping children and girls unselfconscious, since they won't know that this small lens is getting such intimate close-ups of them. On the beach, girls won't even know which part of their anatomy you are aiming at.

105MM SUPER-TAKUMAR, f/2.8. Five elements. Minimum aperture, f/22. Minimum focusing distance, 4 feet. Angle of view, 23°. Weight, 9.9 ounces.

When selecting from the range of lenses above 55mm, it might make sense to skip every other focal length; certainly this is the way to expand your kit at first, filling in any needed focal lengths later. Thus, if you have an 85mm, you could jump over the 105mm to the 135mm. On the other hand, if you've skipped from 55mm to 105mm, your next step might be the rather big one of going to a 200mm.

The 135mm and 150mm Super-Takumars

Weighing a choice in this way you might also select either of two 135mm lenses or the 150mm Super-Takumar. These three lenses are close in weight, size, speed and also in price. They are excellent medium telephotos and are useful for "tight" portraits. They focus to as close as five and six feet. With them a head will fill the frame from about ten feet, and from 30 feet a person just about fills the negative.

The short length and light weight of these three lenses make them easy to carry and to hand-hold. However, you should be two to three times steadier with them than with a 50mm lens, or use shutter speeds that are two or three times faster than those that give you steadiness with normal focal lengths.

With the 135mm lens, you begin to really see the compressing effect of telephoto lenses on various planes of distance. Yet, when you focus on 30 feet and open up to f/3.5, you will have acceptable sharpness only for a space of 3 feet 4 inches. Closed down to f/22, your zone of depth will expand to almost 24 feet. So that you'll know that long lenses have limitations, consider that at its closest focusing of five feet, and wide open to f/3.5, this lens gives 1¼ inches of sharpness.

135MM SUPER-TAKUMAR, f/2.5. Five elements. Minimum aperture, f/22. Minimum focusing distance, 5 feet. Angle of view, 18°. Weight, 15.8 ounces.

135MM SUPER-TAKUMAR, f/3.5. Five elements. Minimum aperture, f/22. Minimum focusing distance, 5 feet. Angle of view, 18°. Weight, 12.4 ounces.

150MM SUPER-TAKUMAR, f/4. Five elements. Minimum aperture, f/22. Minimum focusing distance, 6 feet. Angle of view, 16.5°. Weight, 11.3 ounces.

The Zoom Takumar

There has been some resistance to zoom lenses because they seldom produce really sharp, distortion-free pictures. If you'd like to see some that are sharp, try the Pentax 70–150mm Zoom-Takumar; it is hard to believe that such crisp images come through 14 elements of optical glass.

Another great thing about this lens is the large zoom collar that rides back and forth with satin smoothness as you zoom in and out. The result is that as you pull an image in toward you or push it away to find the most effective composition or follow action, this collar is perfectly balanced to prevent you from losing focus. The lens is fully automatic.

A 70mm image is somewhat larger than the eye or a normal focal length lens sees it; zooming from 70mm to 150mm more than doubles its size.

Strictly a fine, professional lens, the Zoom-Takumar has, unfortunately, a price commensurate with its quality.

70–150MM ZOOM-TAKUMAR, f/4.5. Fully automatic; 14 elements. Minimum aperture, f/22. Minimum focusing distance, six feet with close-focus lens provided. Angles of view, 35° to 16.5°. Weight, 39.5 ounces.

The Zoom Super-Takumar, 70-150mm, f/4.5.

The Telephotos: 200mm
to 1000mm

BEGINNING WITH 200MM we enter new worlds of radical change in what lenses see, and we find sharply increasing limitations and rewards in the pictures that can be made with them. Since a versatile array might include three of the shorter lenses and only one of the telephotos, they can be examined more briefly.

There are five focal lengths of Takumars and newer Supers in the longer group: 200mm, 300mm, 400mm, 500mm and 1000mm. These cover a great range of image magnification, decreasing depth of field, and altered apparent perspective, with greater steps between lenses than are found between the shorter focal lengths, from 17mm to 150mm. The 200mm lens enlarges what you see on the negative by four times, the 500mm by ten times and the 1000mm by 20 times.

What this means in a print is that a negative taken with a 200mm lens, easily enlarged ten times, can give you a picture about 40 times larger than the eye sees it in life. With the 500mm a ten-times enlargement produces a picture that is almost 100 times larger. Yet with the sharpness of Takumar telephotos, 15-times enlargements can be made easily.

Dramatic as this can be, it is nevertheless true that mere increase in image size by itself can helpfully bring things closer for the photographer without contributing much excitement to his picture. Yet a scene can often be made more interesting when shot from far away with a telephoto than it would be from nearby with a normal lens. Good telephoto pictures of things that we know can't normally be approached closely—sports, wild animals, people caught unawares—do have dramatic impact. They can be made even better by putting the other characteristics of telephoto lenses to work.

The creative qualities of telephotos are compression of space and shallow depth-of-field. Compression of planes has the effect of making the near and the distant seem much closer to each other, the reverse of the wide-angle effect. The tele-

Raffish bird, above, was caught by 200mm lens from 30 feet, 1/125 at f/6.3. Daughter, below, was unaware of camera at 35 feet with 200mm lens; 1/500 at f/9. Note backgrounds thrown out of focus.

photo "pulls things together" toward each other and toward the camera in a way that the eye never sees. If you photograph a person waving at a departing ship and use a normal lens, the ship will appear its normal distance away; if you back up with a telephoto until the person is the same size as in the previous picture, your telephoto will make the ship appear much larger and nearer to the person. Shoot down the length of a beach and a telephoto crowds the people toward each other and toward you, making the beach nearer and more crowded. You've seen telephoto shots of traffic-jammed roads that pack the cars even more densely than they seem when you are in one of them.

The third telephoto effect is shallow depth. This can be a limitation, but there's no sense fighting an iron law of optics. When one becomes familiar with viewing through a particular telephoto, and can predict generally what depth it will give at various distances and apertures, this shallowness turns into an asset. Pictures that would be banal with everything in focus will come to life when the main subject is isolated from foreground and background. Even certain portraits achieve an intense concentration of interest when the eyes are sharp but the ears are starting to go out of focus.

Since the creative telephoto effects are more pronounced at nearer distances, it would be a mistake to neglect the really interesting and more intimate pictures that can be made with the telephoto lenses at distances from ten to 50 feet.

The problem of choosing your first telephoto is simplified by the wide differences in their results, and by rapidly increasing factors of weight, cost and other limitations.

The 200mm and 300mm, automatic and manual

These lenses can be hand-held at fast shutter speeds. There is a choice of three in each focal length: a Super-Takumar f/4; a fast, heavier preset or manual Takumar, and a slower, lighter and less expensive lens (see below).

The heavier 200mm and all three 300mm lenses have tripod mounting sockets that are part of a neat housing which revolves so that while the camera is on the tripod it can be easily leveled and you can switch quickly from horizontal to vertical framing.

The first choices, of course, are the 200mm and 300mm Super-Takumars because of their automatic feature and top

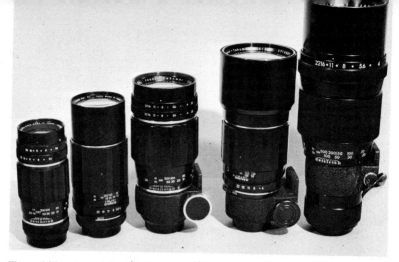

Three 200mm's at left: f/5.6 preset, f/4 auto and f/3.5 preset. Two 300mm's are f/4 auto and f/4 manual. There is also a 300mm f/6.3 preset.

design. Between the others, considerable differences in weight, length, maximum aperture (listed below) and price should make choosing easy. Note that the 200mm f/5.6 weighs only half as much as the faster f/3.5, and the 300mm f/6.3 weighs less than half as much as the f/4. On the other hand, greater speed is important in weak light, in color work and in the advantage of brighter viewing and focusing.

If an image magnified six times instead of four times is important to you, and a longer, heavier and harder-to-hand-hold lens doesn't detract from the kind of pictures you plan, then the 300mm may be your telephoto selection. Some kind of pistol or rifle grip is recommended for most hand-holding.

Otherwise, the light weight, short length and closer-focusing of the 200mm give it important advantages. This lens is wonderful for close situations as well as for distant scenes. It takes "tight" and candid head portraits at 20 feet; fine bird, nature and zoo pictures and many fairly distant sport shots. It is fast enough with high-speed film for theater, ballet and other interior low-light, distant shots. For newsmen covering hearings, UN meetings and similar work, it is practically a necessity.

200MM SUPER-TAKUMAR, f/4. Five elements. Minimum aperture, f/22. Minimum focusing distance, 8 feet. Angle of view, 12°. Weight, 19.7 ounces.

200MM TAKUMAR, f/3.5. Preset, with click stops. Four elements. Minimum aperture, f/22. Minimum focusing distance, 8.2 feet. Angle of view, 12°. Weight, 31 ounces.

200MM TAKUMAR, f/5.6. Preset, with click stops. Five elements. Minimum aperture, f/22. Minimum focusing distance, 8.2 feet. Angle of view, 12°. Weight, 14.2 ounces.

300MM SUPER-TAKUMAR, f/4. Five elements. Minimum aperture, f/22. Minimum focusing distance, 18 feet. Angle of view, 8°. Weight, 33.5 ounces.

300MM TAKUMAR, f/4. Manual, with click stops. Four elements. Minimum aperture, f/22. Minimum focusing distance, 18 feet. Angle of view, 8°. Weight, 53.5 ounces.

300MM TAKUMAR, f/6.3. Preset, with click stops. Five elements. Minimum aperture, f/32. Minimum focusing distance, 18 feet. Angle of view, 8°. Weight, 25¾ ounces.

Above Takumars come with lens hoods and cases.

A "small" 400mm telephoto

A real "sleeper" among telephoto lenses is the 400mm Tele-Takumar f/5.6. Consider that it weighs less than 3 pounds, while the 500mm Takumar weighs over 7½ pounds, and think which you'd rather carry. Also, this lens can be hand-held at 1/250 second.

400MM TAKUMAR, f/5.6. Manual with click stops. Five elements. Minimum aperture, f/22. Closest focus, 27 feet. Angle of view, 6°. Weight, 2 pounds, 13 ounces.

The big guns: 500mm and 1000mm

If one wants to fill the frame with a picture of something barely visible to the naked eye, the 500mm Takumar with its almost ten-times magnification over the 55mm lens will do the job with edge-to-edge coverage of high resolution. Its comparative light weight (less than eight pounds) and bright f/4.5 image make it a fine and practical extreme telephoto. Its 5° angle of view will bring you up close to things that are miles away. Yet it focuses to 33 feet.

A few warnings are in order for the uninitiated. This and the 1000mm lens can bring you many problems. You'll always need a tripod—and a very sturdy one. Neither lens will hold steady enough in a breeze, even with the tripod, unless anchored front and rear. For distant scenes you can

55mm view

Image size isn't everything, but these Takumar telephoto shots of Mt. Rushmore are dramatic. The 55mm lens view contrasted with the 500mm and 1000mm lenses. Honeywell photographs by Jack Swanburg.

500mm view

1000mm view

use them only on clear, bright, cool days—otherwise heat waves or atmosphere haze may spoil your pictures. Filters for these sizes, however, get cheaper; you mount small 49mm ones on the rear of the lens. Good, optically flat ones like those supplied by Honeywell are necessary for long lenses.

500MM TAKUMAR, f/4.5. Manual. Four elements. Minimum aperture, f/45. Minimum focusing distance, 33 feet. Angle of view, 5°. Weight, 7¾ pounds. Attached lens hood.

I've used the 1000mm Takumar only once, but it was a startling experience to look down on Central Park from the 32nd floor of the St. Moritz Hotel and make out the faces of people who were mere specks to the eye. It is like a 40-inch telescope with the aberrations removed. The results proved the lens a fine piece of optics. I decided it would be fun to have one, but that it is a tool for the specialist, the scientist, the professional sports, wildlife or astronomical photographer. It's just the lens I'd want for covering nuclear tests. It would be nice to make your own fine-grain negatives of the moon and blow them up to 16 x 20 inches. This $1,200 lens has recently been made more compact; it is 29 inches long, weighs under 12 pounds and has a custom metal case. Its special tripod has been reduced from 26 pounds to 6 pounds, 4 ounces and comes in a special leather and canvas case.

1000MM TAKUMAR, f/8. Manual. Five elements. Minimum focusing distance, 98 feet. Angle of view, 2.5°. Weight, 11 pounds, 8 ounces. With tripod, built-on lens hood and cases.

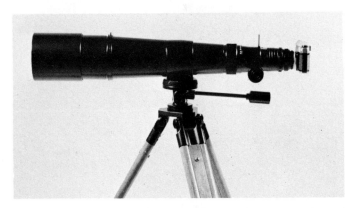

The 1000mm Takumar lens and tripod.

Better Subjects and Better Pictures

SHOWN A PRIZE-WINNING photograph of a woman jumping out of a hotel window, Morris Gordon once remarked: "What's so great about that? It's just f/11—and be there." Nevertheless, good subject matter certainly makes it easier to take good photographs; being a good photographer makes them better, and helps rescue the dull and difficult.

As subjects go, people in all their diversity and perversity are the best. Surveys of photographers show that portraits, groups and candids are favorite interests. Next comes action, always more appealing when it involves the human species. After that come landscapes, and these often gain too by having figures in them, fore and aft. So this chapter concerns itself largely with techniques for handling people— when that gleam in your eye is photographic. Then it deals briefly with scenics, action and close-ups, and comments on some common picture faults.

The small, fast-shooting, no-fuss Pentax comes into its own when it is pointed at people. Its bright reflex finder enables us to see delicate expressions and relationships, even in poor light; its smooth shutter release catches crucial moments; seeing what we take allows us to bring wanted people into focus and throw out unwanted ones with impunity. Obviously, the speed and depth of a 35mm camera make it ideal for following people on the run and for capturing them naturally and in depth—both of field and of feeling.

The candid approach

Candid photographs are often thought of as "sneak shots," as pictures taken by natural light, or as those in which the subjects are relatively unaware of the camera. Beyond that, however, candids should really tell us something revealingly human, and they do this almost always by catching emotion. The sense of unawareness is only part of the more important and positive quality of actuality, the immediacy of

reality brought right to us. The light doesn't matter as long as it is natural in its results.

Most of the people around us spend at least some of their time doing interesting things. Undisturbed, they show themselves amused or sad, intense or relaxed, proud or perplexed. These and a thousand other feelings and moods give meaning to what they are doing. How do we get in close to them and allow them to go on acting naturally?

I believe that looking for sneak candids is a snare, since they are usually dull and always hard to find. You can't sneak very close, nor be furtive in intimate scenes.

The best approach to candids, paradoxically, is to move right in openly but casually and start taking pictures. Once we've established our presence and Pentax we try to fade into the woodwork. From there on, a small bag of equipment and another one of tricks help us to be as unobtrusive as possible.

Let's look at ourselves as we slip into an office conference, sit in on a PTA committee, happen upon a colorful street scene, try to "cover" a teen-age party, or otherwise become conspicuous in an intimate setting.

The first key to success with this kind of picture taking is simply restraint. We obviously don't want to "direct," since asking that something be done for the camera destroys part of the reality that should unfold by itself. People will naturally want to involve us and we must put them off gracefully, resisting the temptation to participate. So we are casual, pleasant and friendly, but also neutral, vague and at times unresponsive.

Hiding in groups

After achieving an introvert shyness in such a small group, we must then draw on our extrovert nerve and start shooting. We are after revelations of feeling and personality, moments of conflict, expressive portraits in action; if we are lucky, a mere expression that is strong or subtle enough will make a picture all by itself. Our relation to such a scene is a delicate one. Each photographer must find his own techniques for dealing with this, but if they come naturally it will be surprising how much of reality can be preserved and how far your camera can penetrate privacies.

It is often wise, in small groups, to shoot a few pre-

liminary pictures of nothing special. Those first few clicks of the shutter reveal our intentions and signal that we are not out to embarrass anyone. People relax a bit and get on with their business.

When a camera is poked at people close up they logically want to ask questions, sound you out, perhaps "act right" for the camera. Some want to talk about photography—not realizing that this would spoil yours. When they dart those questioning glances I smile vaguely, mumble an answer, stare past them or look down and fiddle with my camera. When someone is about to do something I aim the camera elsewhere and watch for the right moment out of the corner of my eye.

Little crises make "big" pictures

The best situations for candids are the ones in which people are so actively engaged that what they are doing holds their interest more strongly than the presence of a camera. People at work, whether in an office or aboard a fishing boat, in sports of all kinds, children doing almost anything; so, too, dances, parties, picnics and even nature walks, all have their moments.

Life's little crises, as well as its weighty ones, add significance to the candid. They can yield fine pictures and sometimes entire stories. If one would follow a good cook through a tough new recipe, a picture of a triumphant moment in the kitchen might emerge. A sequence of gossip over a back fence could build up to a couple of telling expressions. There are many minor crises in the playroom, if we are patient—as when junior turns from happy play with sister to crown his little rival with a toy. The night the dog has pups can make a good picture . . . of your children's reactions.

The photo-journalist of course searches for crises with broader significance: a turning point in a celebrity's career, the team of scientists when an experiment succeeds, a space engineer when his guidance system works or fails, the lady who has just won a prize, people in trouble anywhere.

Making pictures happen

We can't always wait passively for candid picture sessions to present themselves. They often must be set in motion, but preferably in such a way that they take on a

A set up for candids. Patrons in a British pub were asked to taste American bourbon for the first time. Scene was lit with Strobonar 72A.

real momentum of their own. We may want a picture of a group—such as family, a committee, prize winners, the old gang. Assembled for their daguerreotype, they are helped to defrost if we give them something on which to center their attention. This will pull the picture together, suggest an arrangement of the bodies in some natural grouping, give everyone the same thing to be expressive about. Tossing out topics of conversation that will provoke reactions—among the group, not toward us—will help animate everyone.

Give yourself assignments

One thing that makes an amateur hang back from good picture situations is that he lacks a psychological advantage enjoyed by the professional: the push that comes from having an assignment. The amateur has the advantage in not needing to take any particular picture, while the professional must get out (or get in) and bring back results.

The pressure of an assignment does work wonders. It gives us a ticket of entry, a reason for invading privacies, an impetus to work harder, the excuse to keep family or friends waiting until we get our shot. Having their own goals gives some photographers enough drive. To bolster the urge to do purely amateur kinds of pictures I try to keep a mental list of "assignments" to give myself. Perhaps some of these will suggest other projects that fit readers' own interests.

The story of my two daughters' growing up has become a long-drawn-out documentary, helpfully advanced by some pictures for this book. Another is a record, in black-and-white and in color, of the seasons on my acre of woods,

with close-ups of insects and flowers and telephoto shots of birds. An occasional enthusiasm is a series on people living along the edge of the Hudson River, with a companion set of color slides on ginger breaded "carpenter Gothic" houses in the Hudson Valley. Some day I hope our local newspaper will let me photograph the scenes behind its weekly "Personals" column. I'd like to accompany the volunteer fire department on a "hot" call. It would be interesting to shock one's fellow-citizens with pictures of the more unkempt and neglected areas of town.

Such projects solve another problem: Who is going to look at our pictures? A slide showing or album on one theme, especially a local one, will get far more enthusiastic audiences than a collection of unrelated pretty pictures.

The experienced amateur might be more ambitious and do many community services with his camera; these would gain him access to good pictures of people and an audience for them too. Would your PTA welcome a showing of pictures on how a new language program is being introduced in the elementary school? An exhibit on themselves might bring more kids and teen-agers to the recreation center. Can the need for a new park be dramatized by showing where kids are forced to play now? Could your photographs aid some political issue you believe in?

That little Pentax is no sissy. It can be put to serious work.

None of the above projects may be to your taste. They are meant merely to suggest the push you get from having some purpose in your photography. When you stick your neck out, if only with yourself, you are driven a bit to excel, and to deliver.

This pub patron was not in original scene. His reaction to the bourbon called for quickly turning from set-up for "grab" shots by room light.

Informal portraits

Portraits in the **35mm** candid manner are popular today and their value comes from working quickly and flexibly to use Pentax advantages. It will be assumed that the owner of a Pentax is not going in very seriously for the formal studio kind of portraiture designed to flatter ladies and embalm men; for that work you really should have studio lights, diffusion lenses and a large negative for touching out warts, wens and wrinkles. The Pentax lends itself ideally to opposite and more exciting **kinds** of portraits in color as well as black and white: the informal and more realistic. Even executives are submitting to **them** these days, and most of the large size portraits of businessmen in *Fortune,* for example, are made with the Pentax and other 35mm cameras and with natural or simple lighting.

Sitting for a portrait is not relaxing for most people and they need all the help we can give them to appear natural. If you have a third person present who is out of camera range, it prevents your subject from looking at the camera, and he can keep up a conversation that allows him to loosen up his facial muscles and express himself. The choice of a third person may determine the mood that can be caught in your subject. A gay person might make jokes that would be fine for a happy picture of a friend but not necessarily what an executive client would have in mind.

Lenses of 85mm to 135mm, particularly if they are automatic, are best for casual and less posed portraits, and help reduce camera shyness. They also give more control of backgrounds, both in reducing depth and allowing selective narrow angles of view.

Posing: the problem

Alone with a posed subject we must depend on our conversational ability. Some photographers can impose themselves on their subjects, others skillfully lead them from mood to mood. Lacking such talents we can at least be prepared with some topics that will stimulate our subject.

The homely, the plain and the wrinkled are best dealt with by trying to bring out lively expressions that often will transform their faces. Soft, diffused light, such as bounced flood or flash, is a boon (see Chapter VIII). If you are using flash, it is good to have enough other light to see by

clearly in the finder; using it to approximate the direction of the flash helps you to study your lighting, as well as the best angles and the effect of various expressions. Tough subjects, of course, require many exposures.

Shadow is both the worst enemy and the best friend in portraits. It always registers more deeply on film than it seems in life. If you want it that way, you can expose for the highlights and let shadows go dark; the effect is often strong and rich. Direct overhead light, however, blacks out eye sockets, and that is never good. If you have strong light on one side of a face, and don't want shadows too deep, you must get more light on the other side, shift your angle or shift your subject.

People can't be "bracketed"

It is sometimes prudent to "bracket" exposures, to take the same picture over again first at more and then at less exposure than the one originally picked as correct. This is good for safety and for getting different effects. But it only works for scenes that hold still for us. It is seldom feasible for people or action. With these, the scene itself keeps changing, a different picture constantly presents itself, and bracketing brings the risk of the wrong exposure on the best picture.

Bracketing, because of uncertainty about exposure, is a waste of both film and picture opportunities. The only answer is to work carefully until you can shoot an entire roll under different conditions with all exposures in a usable range. This is one to two stops over- or under-exposed for good black-and-white negatives and no more than a half-stop for color.

The time to burn up film is when there is a good scene that keeps shifting and making different pictures. These occasions are rare enough, often fleeting, and are worth thorough exploration for story-telling content, better angles and meaningful moments. When you keep trying for the best single shot you may wind up with a sequence or a story.

People's moods are unpredictable, changing from second to second. Will the picture compose itself better in a moment, or will it fall apart? Not knowing, we shoot what we've got and watch for a better chance. An unexpected remark lights up a face yet composition is poor; we shoot now and try again for a better angle.

For good candids the finger must be faster than the eye.

Photographers not accustomed to rapid shooting may feel some inertia in presssing the shutter and wasting a frame; this needs to be overcome, and the soft, smooth Pentax shutter release is a help.

In almost all photographs with people in them the problem of exposure is simplified: expose for skin tones only. Let other things go dark or wash out. You needn't disturb a scene by holding a light meter up to people's faces; just read the exposure from your own hand—if you are the same color as your subjects. With overhead light it is important to tilt the hand vertically so that some of the shadows are read; otherwise, detail will be lost in the similar shadows on your subjects' faces.

More lively landscapes

Fine photographs can be made of serene and unpeopled landscapes with a good 35mm camera, and they are especially satisfying when projected in color. But we avoid the lifelessness of picture postcards more easily if we push our Pentax advantages and use the speed of new films. These allow us to get action, movement and people into our landscapes. They also open up the great pictorial advantages of shooting outdoors when the sun isn't shining.

New moods are brought to landscapes and cityscapes when they are pelted with rain. Wrapped in mist or fog, or when dark clouds threaten, they take on emotional values. Even the murky river of a dismal factory town can have enchantment in a fog. When light mist separates the planes of distance in a scene, nature has set up a series of filters for us.

With medium-speed film or fast color on a bright day we can be in focus from some foreground grass four feet or so from the camera all the way out to infinity beyond the distant mountains. A breeze can be blowing the grass and we stop its movement; people can be milling about or an airplane flying through, and we've got 1/250 second to freeze them all. There's enough exposure left for a filter to bring in white clouds. This cluttered picture is hypothetical (thank goodness!), but is figured for ASA 200 in sunlight, and an aperture of f/16.

Mist provided "filters" in Croton Bay scene. Shot from running motorboat, 1/250 at f/5.6, ASA 200.

For a scene that demands great speed and great depth, why be stopped by advice against using Tri-X Pan outdoors? By doubling its ASA rating to 800 we can use 1/1000 second at f/22 in bright sunlight.

All focal lengths of lenses have their place in scenic photography, from the deep wide angle for broad sweeps to the shallow and selective view of extreme telephotos. Filters are essential, especially the UV and light yellow (see chapter on accessories).

Action

There is only one workable rule for stopping fast, continuous action: use the highest possible shutter speed. If there are moments when the action reaches a peak, as with a child on a swing, that may be your moment for a slower speed. Hy Peskin once covered a baseball game with a simple box Brownie using this principle; his action-stopping results made *Life's* "Speaking of Pictures" section.

Close-ups without gadgets

The use of accessories for ultra close-ups is dealt with in the last chapter. Even without attachments the Honeywell Pentax focuses for very close close-ups. This is 18 inches for the current 55mm lenses. At 18 inches with these your frame takes in an area of 5 x 7½ inches; enlarged to 8 x 10 it will be larger than life size.

Thus it is possible quickly and easily to copy documents, photograph details of paintings, shoot entire small sculptures and other interesting things in museums, usually by available light and by hand-holding the camera. Depth-of-field is limited: at 18 inches and f/1.8 it is less than half an inch, but at f/16 it is about two inches. When you are focused on the important plane in such pictures, however, the dramatic quality of the close-uppitiness frequently offsets the falling off of sharpness. I've shot frame-filling heads of small animals this way, as well as fish in aquariums and even people in side-face.

A few photo faults

Here are some mistakes I have found most common, even with somewhat advanced photographers. The first three are more serious with 35mm photographs.

Exposure. In black-and-white, the less recognizable fault is overexposure. Negatives should be the thinnest possible that will still hold shadow detail. This gives three advantages: they are easier to print, you get more speed from your film, and there will be much less grain and consequently sharper definition.

Subject too far from camera. Tight framing squeezes the most quality out of the tiny negative or color transparency. Even pros rely too much on cropping afterward, and you can't readily crop out parts of color slides. Study your pictures before printing (see "Contact prints" section in Chapter X) and check how much they can be improved by elimination. If this is a consistent fault, it may be due to timidity in moving in closely enough.

Taken with 105mm Auto-Takumar at 1/1000 second.

Camera movement. Very slight camera movement is hard to detect in a print, but it degrades the image. It is the greatest cause of uncrisp pictures at slow shutter speeds.

Wrong moment. It takes much practice to be neither trigger-happy nor trigger-shy: It is possible to shoot many pictures rapidly and still miss the precisely right fraction of a second. You must anticipate a picture about to happen and start pressing the release before it does. Good practice in hitting the peak of action and expression can be gained by shooting sports, plays and sequences of fast action, such as feeding time at the seal pool in the zoo.

Wrong angles. Two ping-pong players shot from a right angle are each placed on the far sides of your frame, with a picture void between them. If, instead, you shoot over the shoulder of one and get the other facing you dramatically, you will then fill the frame, get closer to the action and have the nearby player's head for foreground interest. Empty spaces are disturbing; maneuver for an angle that will fill them or avoid them. Often the nearest foreground objects are too far away from the camera and there is a void in the depth of the picture; something in the nearby space adds a sense of depth, even if it is out of focus.

Cluttered backgrounds. Greater consciousness of meaningless and distracting elements also takes practice in viewing, and in learning from our mistakes. Single-lens Pentax viewing helps, since we needn't just hope that something in the background will go out of focus—we see whether it does or not. This viewing helps psychologically, too, because it accustoms you to expect everything seen in the finder to turn up in the photograph. If you can't shift subjects away from busy backgrounds, then change your angle of view to either side, or shoot up or down at them. While simple backgrounds are better than busy ones, meaningful ones are best of all. A wall full of a craftman's tools will hardly detract from his portrait.

How Some Prize Winners Used the Pentax

Light is the photographer's paintbrush. Sometimes it is unobtrusive, letting the subject speak for itself. Often, though, the character of the lighting is the unique thing about a photograph. But light "speaks" through exposure, which is the photographer's decision.

Here are five pictures from the Honeywell/Asahi International Photo Contest, all of them sixth to eighth place winners. They were picked for two things they have in common: each was taken by natural light and each involves the kind of subject that anyone might find. But only one, that of the girl on a horse, is a straightforward exposure. It apparently was taken on a softly overcast day.

Some of these pictures are purposely exposed for only one part of the subject, for special effects, while others make a fine compromise. The children on a dock are correctly exposed for themselves, but the rest of the scene is thoroughly overexposed—no compromise here.

The picture of a duck, likewise, is exposed correctly for the duck but the rather overexposed water makes an abstract pattern, and that makes the picture.

The wheat field is slightly underexposed for the field and trees, allowing the mist to etch deep contrasts into the receding landscape. The cat picture is slightly overexposed for the bright sunlight and underexposed for the barn interior, a compromise that worked.

The point is a simple reminder to think twice about exposure. Often there is not just a single correct one for a scene, but several.

With a 105mm Takumar on an H-3 Pentax, David Camhi of Brooklyn, N. Y., exposed for the duck and let overexposed water form an abstract pattern.

Using a correct exposure for the children on the dock, Thomas DeFea, of Des Moines, Iowa, let brightly lighted water wash out in overexposure.

The softly overcast daylight in the scene made exposure easy for this moment caught "at the end of a run" by Ernest Rosenfeld, New York City.

Mist outlining distant hills was probably selected for his exposure by Alan Shayne of New York City, letting rest of scene go dark for contrast.

Contrasty light at barn door required exact compromise between bright and dark areas. By Cardine H. Arndt, Littleton, Colo. with Pentax H–1a.

Light: Natural and Naturalistic

THIS CHAPTER IS a subjective guide to the steps from existing to controlled light. It suggests a full exploration of light as we find it. It advises a wide use of simple photofloods in natural ways. Then it strongly recommends that you consider skipping over conventional flashbulbs in favor of electronic flash, if the initial outlay makes sense for your kind of photography. The flexible technique presented to simplify controlled sources is bounced light.

The aim is always to use or strengthen natural light or to simulate it, with emphasis on how to light situations with people in them while at the same time keeping the people relaxed and natural.

Therefore, you will not find on these pages such complicated directions as those often given for placing three lights on a patient model and then measuring distances and calculating exposures for key light, modeling light and halo light. These are not avoided to save trouble but because you can get more elegant and more flexible lighting quite simply and be free to capture the spontaneous and relaxed qualities of your subjects. Contrived lighting creates both unnatural pictures and unnatural expressions. If one goes into studio techniques, perhaps for portraits, it is wise to bring to them the good taste that comes from a feeling for the natural in lighting—as well as in people, props and processing.

Daylight, existing artificial light and photofloods share two tremendous advantages over flash: you can see what the results are going to be, with your eye or Pentax viewfinder, and you can measure them precisely with a meter.

Daylight, electric light and combinations of the two give us more varieties of interesting and subtle effects than anyone could invent. The problems they present often force us to be creative, or at least ingenious. Learning to look for

their possibilities and happy accidents, and to predict how they will turn out on negatives, is a study that never stales. Here too, Pentax single-lens viewing aids our eyes' education.

Available light

Exploring the infinite varieties of natural and man-made existing light is not just an amateur's logical point of beginning. Most great photographs that we see have been made by existing light, from Brady to Cartier-Bresson. Some of the most talented photographers of our electronic age still use nothing else.

Certainly, we can't outgrow the light that is most interesting and natural, yet costs nothing. It frees us from clumsy equipment and we do not upset our subjects with set-ups, bulb-changing and bright flashes.

Those who have not taken many pictures in low levels of artificial light may be missing both fun and fine pictures. The following examples hint at the possibilities, but are not meant as exact exposure guides; take your own meter readings of such situations. Use a film of 400 ASA, which can be rated easily at 800, and in emergencies at an index of 1200 or even 1600; developing times for increased speed are given in the chapter on darkroom hints.

In well-lighted offices, supermarkets and some living rooms I have taken many pictures at 1/60 second and f/4 to f/6.3. With daylight from windows, less exposure is needed. Museums and galleries are often lighted for at least an extra lens opening of speed.

Factories, however, even when lighted as brightly from above as offices, reflect much less of the light about horizontally; walls are farther away, ceilings are higher, floors darker. I've usually found that 1/30 at f/3.5 to f/5.6 is adequate.

Recently I was able to take pictures in a dance hall, very dimly lighted from overhead, by using the light from candles on tables to fill in nearby faces. At ASA 400, these exposures were made at 1/15 and f/2.

In many auditoriums, gymnasiums, convention halls and ballrooms, I've found light too dim to register on conventional meters. But with a sensitive battery-powered meter and ASA 400 film rated at 1200 to 1600, exposures were possible at 1/30 and f/3.2 to 1/15 at f/2. The film was a bit rugged in grain, but the pictures were superior to those made with direct flash in the same large, dim halls.

72

I've also taken pictures of people just two or three feet from a bare 50-watt bulb, at 1/50 and f/3.5, but a little added general illumination helps such stark lighting.

I've found that spotlights on floor shows in nightclubs, at the circus and in some theaters will give a range at 1/60 from f/5.6 down to 1/30 at f/2.8. Bright carbon arc lights give good results with daylight color; try High Speed Ektachrome, 1/60 at f/3.5.

The above random notes merely hint at the areas of usable light easily accessible to the Pentax. One can go to lower levels. With skill in holding the camera steady at slow speeds, a tripod, an f/1.8 lens and the pushing of film speeds we can challenge the almost-invisible. But it gets increasingly difficult to judge and meter extremely low light. Enthusiasts sometimes forget that low light can be poor in photographic quality, too contrasty or spotty. Direct overhead electric lights can be as "bad" as noonday sun.

To improve available light, you should cultivate the habit of opening blinds (or closing them against bright sun), turning on more light fixtures, and using such reflectors as come to hand—sheets, pillowcases, newspaper, an open book; or, you can carry around some white cardboard or shelf paper.

When it is possible to maneuver your subject without disturbing what he is doing—or if you are frankly posing someone—by all means maneuver him into better light. When you expect to take pictures in a certain room, as at home, you can replace lamp bulbs with some of higher wattage.

Flexible photofloods

With two #2 reflector photofloods and a feeling for natural light you can go on to lick a host of further low-light and poor light problems. These floods cost about $1.50 apiece. They require no reflectors, but you'll need clamp-on holders and extension cords. A lightweight, collapsible light stand will be very handy.

Begin by not pointing these lights at people, but bounce them off a light-colored ceiling, or even a wall. You may then join me in a rule never to point a light directly at a person if it can be avoided.

Start with a fast ASA 400 film and use a meter. By bouncing the pair of photofloods close together, at one to

three feet from a fairly white ceiling, you can light up average rooms for exposures of as much as 1/60 at f/4 or f/4.5 with no appreciable help from other sources. Leave house lamps on, not only to help with their light, but because they will look natural. Try to use additional light from windows without shooting directly into them on bright days. For color with photofloods see Chapter IX.

The beauties of bounce

With this bounced light you get a very even, soft, over-all illumination of the room. You can meter it, set your exposure and then stick to it without constantly calculating changed lamp-to-subject distances. You needn't worry over where your lights are pointing. Thus bounce, unlike direct light, makes it far easier to follow moving people: children, guests, family, a meeting or a party. You can maneuver all around the room without concern for lighting at all. You don't have to pose and direct people, which leads to pictures of people being posed and directed. You get natural expressions, and your light looks natural.

The beauty of this simple technique is that it preserves our ability to photograph people doing things and reacting naturally to them and to each other, instead of taking pictures of people having their pictures taken.

In addition, with this bounced floodlight, you have no cumbersome flash on your camera, no flash-to-camera wires to worry about, and you do not disturb your subjects once the lights are in place. Clamp them atop open doors, mouldings, shelves, high furniture, or make them more maneuverable by using a light stand that you can shift about.

Note that if you aim both floods at one spot on the ceiling you get twice as much light as with one flood. If you aim them at separate spots you get more even light in the room but the exposure will be the same as for one photoflood, because each will be lighting a different area. Two on one spot and one in another give a better modeling .

If all your shooting will be in one direction, at people facing you, keep the floods more or less behind or beside you so that light bounces toward their faces. You can increase and spread the light farther by tilting the reflector bulbs slightly in the direction you are shooting. (For more on bounce techniques that would apply here, see the next section on electronic flash.)

A pair of photofloods can be used to bounce in a bit of extra general illumination when existing light is weak or spotty; also, to counterbalance light coming in too strongly from windows on one side of a room. Still-life photographs can be made by pointing one flood directly at the object for bright light and highlights, while the other is bounced to reduce but not kill the shadows which give a natural feeling to a picture. In other cases the main source can be diffused daylight coming in a window while the floods are used to balance it and provide controlled highlights.

One continues to find many uses for photofloods, and they are always fun to play with for effects. In some ways they make better pictures than flash, and they teach us a lot about how film records different lighting. There's nothing better for still lifes and ultra-close-ups when you don't need the speed and portability of flash.

But one day you'll want more. Perhaps you'll have plugged in a fourth flood and blown a fuse. Not all locations have outlets. While floods help one learn to hold a camera steady at slow speeds, you'll get tired of pictures that are not always quite sharp. For more light, faster shutter speeds and sharpness, what next: flashbulbs or electronic flash?

Skip flashbulbs?

At the end of this chapter some advantages of flashbulbs for specific uses are given and equipment is suggested for use with the Pentax. But before deciding I believe that you should give serious thought to the greater advantages and potentialities of electronic flash.

Here are some limitations of flashbulbs. You can miss six chances at a good picture—or six pictures—while changing them. They make a fiercer glare in people's eyes than electronic flash, upsetting whatever they are doing or thinking. You become the center of attention while using them. On the camera and directed at people, they usually produce dreadful photographs with people in the foreground washed out and the background underexposed, unless you set up everything carefully beforehand. Multiple flash can be much better, but by the time you string out three wires, change three bulbs and set off the explosion, your problems become multiple, too, and will have killed the chance for natural or expressive pictures.

Daughter's 11th birthday party was shot by strong daylight from right, bounced Strobonar on left. This light preserved natural appearance, even of candles. The 35mm f/2.3 lens on a Pentax also caught pensive portrait of her, below. Distortion of wide angle was avoided by using only two-thirds of frame. Tri-X Pan at 400 ASA, 1/50 at f/8.

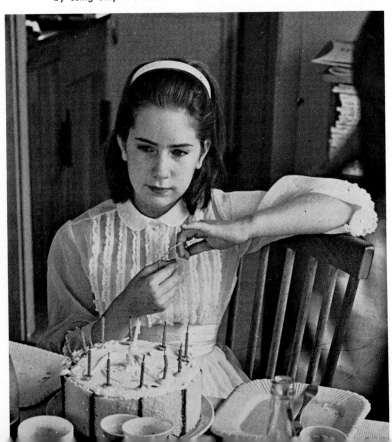

Single flash, especially from the camera, produces harsh shadows. Hand-holding off the camera is awkward. If you set up for a single off-camera flash the improvement may not be great and the bulb may become inaccessible for changing. Lighted lamps in a room are overwhelmed by the power of direct flash, and windows become black holes or glaring reflectors, the light falls off rapidly and the natural appearance of the room is destroyed. Fast focal-plane shutter speeds require long-peak bulbs that are more distracting than ever to your subjects. You need blue bulbs for color.

Bouncing single flashbulbs overcomes objections to quality of light, and when done on the camera is not so inconvenient. The tiny and inexpensive Honeywell Tilt-A-Mite, discussed under "flashbulbs" at the end of this chapter, has a lamphead that swivels for bounce and takes all three types of bulbs without an adapter. In using such a unit much of the previous discussion of bounce advantages with floods, and in the next section, on electronic flash, will be useful.

If you are not ready for electronic flash—good portable units do run over $50 in price—bear with the electronic argument and we'll come back to flashbulbs.

Electronic flash

These units today come in a wide selection of prices, light outputs and several other important specifications. Some work only on batteries, others on house current, a few on either. Some have rechargeable, permanent batteries. Most good small ones flash at 1/1000 second or faster, recycle in two to six seconds, and pour out a lot of light that causes far less distraction and discomfort than flashbulbs. The cost per flash is low. Light temperature is nicely balanced for daylight color, and can be mixed with daylight when using color; no filters are needed. There's no changing of bulbs, a prime source of missed pictures and upset situations.

The 1/1000 second and faster duration of electronic flash will show what really sharp, crisp pictures your Pentax lenses are capable of when camera shake and subject movement are eliminated.

However, your pictures won't *look* much different from the flashbulb ones just described if you point the light directly at people, so electronic flash will be presented in terms of bounced light.

Bounced electronic flash—15 ways and wherefores

Ceiling-bounced exposures in average rooms vary surprisingly little. A bright ceiling in a large, somberly furnished room will often take the same exposure as a darker ceiling in a brighter or smaller room. Ceiling height is mostly a matter of one lens opening from an eight-foot to a 12-foot height. You soon learn to judge quite accurately. Exposure formulas for bounce are not very practical; they require you to measure lamp-to-surface-to-subject, add them, divide the result by a guide number, and then use an aperture two stops greater. After that, you begin knocking off f-numbers for off-white, gray and dark ceilings. Among many critical and experienced professional "bouncers," I don't know of one who finds this necessary.

Let us see what can be done with portable units of either a 90-watt-second light output and film of ASA 400, or a 40- to 50-watt-second output and film rated at 800. Clamp the flash lamp head at the top of a door or put it on a light stand so that you can move it about with you or off to one side (you can have it on your camera, with a bracket to aim it at the ceiling, but why be weighed down?). Try to set the lamp about two to three feet from the ceiling. You can tilt it so that its light will glance across the entire ceiling, but not so far that direct light from it spills over into the

Bounced flash with Tilt-A-Mite.

faces of people in the room. (I've broken this rule, too, in emergencies, and the pictures were better than direct flash.) Try to keep the light behind or beside you for more light in eye sockets, less shadow under chins. (Yet, in a bright room, side- or back-lighted bounce can be very pleasing since the facial shadows won't be dark.)

In an average-size room with moderately light ceiling and walls, you are now ready to shoot like mad at f/8 to f/6.3 and have no worry whatsoever about lighting, aperture, camera movement or stopping action—you just have to focus. Well, of course, there's composition and the crucial problem of getting human interest. But human interest comes from catching emotion, fleeting expressions and fast gestures. How much more can equipment do than to stop the exact height of an action, or the split-second peak of an expression, in 1/1000 of a second? You can miss by many thousandths in pressing the release and still get expressive pictures.

Let's examine the beauties and simplicities of this bounced electronic marvel point by point.

1. Bounced electronic flash of portable size will evenly illuminate the entire area of quite large rooms, from all directions, and will fall off very slowly compared to direct light. It will not burn up the foreground.

2. Without changing aperture, you can maneuver all about the room, moving in for close-ups and backing off for

Direct flash with Tilt-A-Mite.

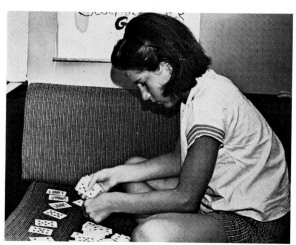

79

broad views and always using the same exposure. The light covers a wide enough area for the widest-angle lenses.

3. Because of its speed, the light will scarcely disturb people. Electronic flash does not blind them, and when bounced it is much less disturbing than direct; your subjects frequently won't even know where the occasional flicker of light is coming from.

4. You don't have to run around changing bulbs.

5. Bounced electronic flash of this power looks natural, appearing as good room light. Moreover, it does not wash out existing lights; lamps and even candles will still be seen in your pictures lighted rather naturally. With care, daylight coming in windows will look natural—in color as well as black-and-white.

6. You can strengthen existing lights, such as lamps, candles or daylighted windows, by using slower shutter speeds to give them more exposure. The flash exposure will remain the same, but 1/30 or 1/15 will allow other light to register more than at 1/50.

7. Electronic flash is perfectly balanced for daylight color film. In bouncing it, however, you must be careful to have a white ceiling and no colored walls nearby that can pick up the light and reflect their own colors back onto your subjects. Anticipating such sites, bring rolls of shelf paper and masking tape and arrive early enough to do a small redecorating job. A three-foot square of white paper taped to a dark ceiling is often the answer to bouncing for both black-and-white and color.

8. The slowest usable units recycle in about 14 seconds (an almost interminable wait when you get accustomed to electronic flash), while the quickest units recycle in less than two seconds; in any event, you are almost always ready to take another picture.

9. You can shoot in any direction in a bounce-lighted room, of course being careful not to get your own flash unit into the picture.

10. If you want to light up big areas or long distances, you can add another unit without using wires; a Honeywell Fotoeye device can be mounted on the second unit and will fire it in synchronization with the master unit. Compact slave units for the same purpose are available.

11. The very slight variations in exposures for bounced electronic flash have a number of advantages. Your ASA 400 film is shot in an average light-colored room at f/8, but it

Informal double portrait by bounced electronic flash. Pentax H–3 with 55mm f/1.8 lens and portable Strobonar. ASA 400, 1/50 at f/6.3.

would take a very bright, tight room with a white floor to bring you up to f /11. A very high ceiling—say 18 feet— in an otherwise bright room might bring you down to f/5.6. A relatively dimly colored room also brings you down to f/5.6. A gray or tan ceiling, or a very dark room with a light ceiling, could call for f/4.5. With no more guidance than the above, you are unlikely to be off more than one stop in exposure; this produces quite printable negatives and further refinement can wait on experience.

12. Electronic flash bounce negatives are generally very printable.

13. They are also about as sharp as you can get. Bounced small electronic flash keeps you in the range of best apertures for sharpness, too.

14. The soft, diffused light of bounce is excellent for portraits, flattering to women, yet is realistic in its effects. Reflections from or on glass, windows, mirrors and shiny surfaces are much less troublesome than with direct light.

15. You can vary bounce by using walls, combinations of walls and ceilings and corners to get more shadows and vary the evenness of the light. You can combine bounce and direct to get the benefits of both.

Electronic flash problem

Before I get submerged in the soft, diffused glow of this electronic marvel, let's take up one of its drawbacks.

On focal-plane cameras like the Pentax, electronic flash cannot be synchronized at high speeds. This is because both of the shutter's curtains must be completely open at the fraction of a second when the flash goes off.

The main danger is in shooting against a bright window when the subject is moving fast enough to blur at 1/50 and the window light is strong enough to register at 1/50. But any brightly-lighted, fast-moving object may give you two images on the same negative—one taken by the camera at 1/50, the other by the flash at 1/1000.

A lesser problem with bounced light is that you can sometimes get shadowed eye-sockets in pictures of people too directly under the light. This can be avoided by having the light slightly behind you, not so near to the ceiling or tilted toward faces. Having other light to work with helps: windows on one side of a room can be kept somewhat behind or beside you, while the flash brightens up the darker side and increases the general illumination. A bounced or direct slave unit located strategically also solves the problem. You can even use a bounced photoflood with bounced flash; in a dark room it enables you to focus more easily.

Electronic units thrive on use. If left idle, their capacitors become electrically deformed and must be formed again by ten or so flashes on battery or house current.

Which electronic unit?

Most of the problems of correct exposure with direct flash are solved by a series of Auto/Strobonars developed by Honeywell to fill a variety of amateur and professional needs. Not only do these units automatically determine and control the amount of light needed for each scene, but they also have a manual setting which allows the photographer to control the light for special effects, bounce flash or for outdoor fill.

In automatic operation the Auto/Strobonars use a tiny sensing "eye" to measure the light reflected back from a scene or subject; when they have "read" enough light for a proper exposure they turn themselves off. If the subject is farther away or dark they allow more light to pour out. If the subject

is closer or brighter, they quench themselves and allow less light.

Responding in millionths of a second, the Auto/Strobonar circuitry can reduce the light output from 1/1000 second to as brief a duration as 1/50,000 second.

Most of these units operate automatically in a range of distances from 2 feet to 23 feet. At 23 feet they allow full light output to reach the subject, and flash duration is 1/1000 second. As the subject and flash come closer to each other, the flash duration is reduced. At 2 feet it is 1/50,000 second.

In automatic operation the aperture is set for the speed of the film being used and nothing further need be done. These Auto/Strobonars free you from calculating exposures, using guide numbers or changing apertures as you vary flash-to-subject distances. You can shoot a large gathering, for example, and then move in for a close "head shot" of one person without changing exposure settings. (Yes, you do still have to focus your camera!)

The high speed flash at close distances gives the average photographer the ability to make stop-action pictures that ordinarily require elaborate and expensive flash equipment. The Auto/Strobonars will freeze the high-speed motion of

Two electronic units were bounced into this scene to get depth and wide coverage without destroying room and window light. Two Strobonars, one behind camera, other behind pillar with Fotoeye. F/5.6 and a shutter speed of 1/30 second to emphasize existing light. ASA 400. H–3 Pentax with a 35mm Takumar lens.

birds' wings, whirling machinery and even the impact of a bullet.

Some of these Auto/Strobonars, numbered 880, 770, 440 and 330 are described briefly below. The first two have counterpart less expensive units without the automatic feature but with the same specifications otherwise. These latter are numbered 800 and 700.

The professional Auto/Strobonar 880 (and non-auto 800). Operates from separate and non-rechargeable 510V battery or AC. Recycles in 2–4 seconds on battery, 3–12 seconds on AC. Kodachrome II guide number 80. Flash duration on automatic, 1/50,000 second to 1/1000 second; on manual, 1/1000 second. Batteries deliver 1000–1500 flashes. Has an open flash button. Can be used as power source for Prox-O-Lites.

The high performance Auto/Strobonar 770 (and non-auto 700). Operates either on four internal and rechargeable batteries or on AC. Also operates on a combination of both to conserve battery charge. Batteries give minimum of 80 flashes per charge. Recycles in 8–15 seconds on battery and 7½ seconds on AC. Flash duration is 1/1000 second (and as short as 1/50,000 second on the 770 in automatic operation). Has open flash button.

The above are improved versions of the 660 and 600 models, but the specifications are identical.

The Strobonar 500. A small, high performance but non-automatic unit with built-in rechargeable batteries and charger. It is designed for shoe-mounting on camera, weighs only 17 ounces and has a Kodachrome II guide number of 50. Recycles in 4–9 seconds to full power on batteries and in about 5 seconds on AC until a half-power indicator lights up. Has open flash button. Batteries give 40–70 flashes per charge. Flash duration is 1/1500 second.

The Auto/Strobonar 440. This small unit is automatic in a range from 2 feet to 14 feet, has a Kodachrome II guide number of 50 (f/4) and built-in rechargeable batteries. Recycle time is 7 seconds on batteries, 20 seconds on AC and only 5 seconds on a combination of both. Flash duration is 1/800 second on manual and as short as 1/30,000 second on automatic. Batteries give about 60 flashes per charge.

The Auto/Strobonar 330. The lowest-priced Strobonar with automatic exposure control. Shoe mounted. Kodachrome II guide number 25 (f/2.8). Recycle time 4–9 seconds on battery and about 5 seconds on AC.

Two small, camera-mounting Strobonars, the 500 with a Kodachrome II guide number of 50 and the automatic 330 with a guide number of 25.

These newer Strobonars use transistors and other solid state circuitry for reliability and longer life. The 770, 700 and 500 have ready lights that turn on only when full power is available.

All the above units except the 440 accept accessory lenses and filters that come in sets. These include a neutral density filter that reduces light output by four f-numbers; a UV filter that slightly warms the light; a wide-angle dispersing lens and a filter for converting the daylight color temperature of the flash to match Type A color film.

Two more specialized units are Honeywell slave units with built-in incandescent modeling lights. These let you preview the exact play of light and shadow that the flash will create. They can be connected to the camera or set off remotely as slaves of a master unit. Multiple lighting allows you to give roundness to a subject, add sidelights or backlight, or to bounce part of the light.

The Strobonar 200 modeling slave has a Kodachrome II guide number of 32, and model 202 has a guide number of 46. The latter has a "low" switch that provides half of its full light output. Both are AC units.

The Strobonar 60S slave unit also has a built-in photo-eye that trips it when another flash goes off, but it operates on a single dry battery. The Kodachrome II guide number is 45.

The Honeywell Fotoeye is an attachment that turns almost any electronic flash unit into a slave. It will synchronize

Two top Auto/Strobonars with Kodachrome II guide numbers of 80. The 770 at left uses rechargeable cells or AC. The 880 professional unit uses AC or a separate 510V cell (case shown at right).

its unit's flash with another one up to 100 feet or more away. You can often light up vast caverns and long hallways with just two portable electronic flash units and a Fotoeye. Sometimes it is possible to hide a second unit behind something in the picture area and just let the Fotoeye peek out.

For shadowless close-ups

Honeywell Prox-O-Lites are a series of circular flash tubes that fit over a camera lens and provide shadowless illumination for close-up photography. Model 7 is designed for Pentax lenses; it screws directly into Series 7 filter rings and lens rings of Pentax lens hoods 782, 783 and 784. Prox-O-Lites have three sources of power: a special power pack, the regular 880 and 800 Strobonars or special "P" models of others, such as the P600. Other Honeywell units can be factory-adapted.

Prox-O-Lites are widely used for scientific and medical close-up work, and their even illumination makes them handy for copying. The perfect daylight color temperature is excellent for color photography of specimens, flowers and stamps. For more on close-up photography see Chapter XII.

Flashbulbs and guns

Flashbulbs have a number of unquestioned advantages. They are cheap, and good flash units themselves are quite inexpensive. Bulbs give out more light than portable electronic flash. If you like to shoot controlled situations artistically and want to use multiple light sources, flash could be more economical.

If you only rarely use your Pentax indoors, and then for family snapshots and similar pictures, flashbulbs will be more practical. You can learn to bounce them, too; but then be certain you get a flash unit with a bracket that lends itself to bounce.

If you frequently need high shutter speeds with flash, then long-peak bulbs will synchronize with the focal-plane shutter at speeds up to 1/500 and 1/1000.

When every indoor picture you take is likely to be carefully set up but you need more light and speed than floods provide, perhaps you should use flash. If that is the case, then perhaps you should use a 4 x 5 camera because you will not be using most of the advantages of 35mm photography, single-lens viewing and the values of the Pentax.

The finest introductory all-around unit for single flash at the camera is Honeywell's tiny Tilt-A-Mite. Its reflector tilts upward through five positions for bouncing light, and can be adjusted for near or far subjects. It folds up to a shirt-pocket size and it takes all three bulb sizes—bayonet, M–2 and AG–1—without adapters. For bounce with the camera held vertically, as with any other flash, you'll need an accessory swivel mount. This unit must be used at or on the camera. It has a test-light button, a trigger for open flash and an exposure dial. There is an adapter for flashcubes.

Flash synchronization

The following table must be followed in using flashbulbs with the H–1a and H–3v. Note that only long-peak focal-plane (FP) bulbs can be used at all shutter speeds; for these, the flash cord must be plugged into the FP terminal on the camera. For other bulbs, the cord must be plugged into the X terminal.

Shutter speed / Flash terminal	$\frac{1}{1000}$ H3v ONLY	$\frac{1}{500}$	$\frac{1}{250}$	$\frac{1}{125}$	$\frac{1}{60}$	X	$\frac{1}{30}$	$\frac{1}{15}$	$\frac{1}{8}$	$\frac{1}{4}$	$\frac{1}{2}$	1	B
FP		FP Class (screw base)	FP Class (screw base)	FP Class (screw base)	FP Class (screw base)								
FP		FP Class (bayonet base)	FP Class (bayonet base)	FP Class (bayonet base)	FP Class (bayonet base)	FP Class (bayonet base)							
X						F Class	F Class	F Class	F Class	F Class	F Class	F Class	F Class
X							M Class	M Class	M Class	M Class	M Class	M Class	M Class
X						Electronic flash	Electronic flash	Electronic flash	Electronic flash	Electronic flash	Electronic flash	Electronic flash	Electronic flash

The following table is for use of flashbulbs with the Pentax Spotmatic:

Shutter speed / Flash terminal	$\frac{1}{1000}$	$\frac{1}{500}$	$\frac{1}{250}$	$\frac{1}{125}$	$\frac{1}{60}$ x	$\frac{1}{30}$	$\frac{1}{15}$	$\frac{1}{8}$	$\frac{1}{4}$	$\frac{1}{2}$	1
FP	FP Class (screw base)	FP Class (screw base)	FP Class (screw base)	FP Class (screw base)	FP Class (screw base)						
FP	FP Class (bayonet base)	FP Class (bayonet base)	FP Class (bayonet base)	FP Class (bayonet base)							
X						FP Class • F Class	FP Class • F Class	FP Class • F Class	FP Class • F Class	FP Class • F Class	FP Class • F Class
X							M Class	M Class	M Class	M Class	M Class
X					Electronic flash	Electronic flash	Electronic flash	Electronic flash	Electronic flash	Electronic flash	Electronic flash

Color Films

NOT LONG AGO our choice among color films was limited to either slow, fine-grain ones that rendered deeply saturated colors or to a relatively few fast, coarse-grained films that rendered color in pastels. Today, while we can face most photographic uncertainties armed with only one kind of black-and-white film, choosing from the wide new array of color films is at times bewildering.

Will we find subjects that are soft, subtly-colored and pastel when what we want are slides that have snap, brilliance and maximum color? Or will we want to have those pale, pastel colors come out faithfully? Will we need to encompass a wide range of color brightness in one picture by using a film of greater latitude—and still have it relatively fast? Today we can make such choices.

Of course you know that each type of color emulsion must be matched with the color quality of light used. Our eye compensates for many differences in the color of light, but color film can't fool itself.

For example, if we first look at a red apple by daylight and then under tungsten electric light we notice little change in the color of the apple, although the latter is much "warmer," that is, redder, than daylight. We think of the apple as retaining its same color in morning, noon and afternoon sunlight, in the shade and under a cloudy sky. Our eye adapts itself and "remembers" the color an apple is supposed to be. Color film would give us a series of quite different apples.

If we use daylight film to photograph our apple under tungsten light, such as photofloods, we get a garishly unnatural red. Late afternoon and early morning sun can also be too "warm" for some pictures; cloudy days and open shade have too much blue.

The remedy for these differences is the use of filters to correct for differences in the color quality of light. Pentax filters for color are listed in the chapter on accessories.

Color films are balanced for light sources by the following types. DAYLIGHT FILMS: These match a mixture of midday sunlight plus skylight, and are used without filters for electronic flash and blue flashbulbs. With blueish daylight (shade, overcast, distant scenes) a skylight or UV filter is helpful. TYPE A FILMS: Represented now only by Kodachrome II Professional Film, Type A, balanced for 3400°K photoflood or quartz-iodide lamps. TYPE B (TUNGSTEN) FILMS: Balanced for use with 3200°K studio floods. They are represented by Anscochrome T/100 and High Speed Ektachrome Type B. TYPE F FILMS: There are no longer any specific films of this type, balanced for clear flash at 3800°K. However, Kodacolor X and Agfacolor negative color are Type F films. When you shoot them in daylight, color correction is made with filters in the lab.

An element that can't be measured and that is difficult to describe exactly in words is the differing characteristics, the color tones, peculiar to each type and make of film. The makers naturally imply that each gives nearly "perfect" color rendition. While an attempt is made in the following notes to roughly characterize each of the more popular and generally available emulsions, another important aspect is one's own taste; perfection is in the eye of the beholder. It must be admitted that most people prefer bold, deeply-colored slides that make everything look "better" than it does in real life—or at least brighter and more colorful. It is good to remember that we can often delight slide audiences with pictures that are appropriately soft and not always posterish, color-saturated and overdone.

Following are main characteristics of current color films. Norman Rothschild has been kind enough to check my adjectives, most of which are "borrowed" from his authoritative articles in *Popular Photography*.

High speed daylight color

Anscochrome 500. ASA 500. Fastest color film on the market. Good color saturation, especially reds, yellows, and greens. Rich blacks. High contrast, fairly coarse grain, with latitude of approximately 3/4 f-number in daylight. May be "pushed" to even higher speeds.

Anscochrome 200. ASA 200. A film with considerably good saturation, but warmer than Anscochrome 64. Moderate contrast. Medium coarse grain, with latitude of less than one f-number.

High speed Ektachrome. ASA 160. Good for delicate, pastel effects but will adequately render strong colors, if they are present in the subject. Capable of recording with fidelity a wide range of brightness in the same picture. Moderately grainy, with latitude of one to one-and-a-half f-numbers.

Medium speed daylight color

Kodachrome X. ASA 64. Color rendition and contrast approach that of older Kodachrome I. Medium saturation, sharp and fine grain. Moderate latitude of one f-number.

Ektachrome X. ASA 64. With more saturation and snap than the above, this film seems to belong to the Kodachrome family instead of to the pastel Ektachromes. Its deep colors are less real but more pleasing to many viewers. Good grain, low contrast, excellent latitude of up to one-and-a-half f-numbers overexposure and two f-numbers underexposure.

Anscochrome 64. ASA 64. Another improved, brilliant-color Ansco film with excellent rendition and better grain and sharpness. Latitude of one to two f-numbers.

Kodachrome II. ASA 25. For full saturation, high resolution sharpness and fine grain, this is still a standard and standby when speed is secondary. One f-number latitude for best results.

Dynachrome 25. ASA 25. A warm, high-saturation film. A latitude of almost two f-numbers allows for error and also records a wide range of brightness in a single scene. Good rendition of deep colors as well as pastels.

Dynachrome 64. ASA 64. Also warm, with a great range of brightness from sunlight to shadows. Low contrast. Good grain. One f-number of latitude, either way.

Agfachrome CT 18. ASA 50. Medium contrast. Gives excellent rendition of neutral colors and seems free of any special color cast. Excellent flesh tones, very good in shade. Latitude of 1½ f-number, either way.

Versatile negative color

Kodacolor-X. ASA 80. Yields *negatives* which must be made into prints or slides at extra cost. Great latitude in exposure and for color correction in printing. Balanced for daylight or blue flash. With electronic flash an 81B filter helps reduce blue. With photofloods and 80B filter, ASA is 25. With 3200° K lamps and an 80A filter, the ASA is 20.

Tungsten color

High speed Ektachrome B. ASA 125. The fastest tungsten color. Rather pastel. Balanced for 3200°K lamps but usable in many available-light tungsten situations. Good latitude, and can be "pushed" to a higher exposure index in processing. For regular 3400°K floods use an 81A filter (ASA 100); in daylight use an 85B (ASA 80).

Anscochrome T/100. Replaces Super Anscochrome Tungsten, has more natural flesh tones, finer grain and better keeping qualities. Balanced for 3200°K lamps but usable under available-light tungsten bulbs. Good latitude. Used outdoors with 85B filter (ASA 80); under 3400°K floods with an 81A (ASA 80).

Color pointers

In general, the standards in commercial color processing are higher than in black-and-white. Still, if you wish to use a local lab for speed and convenience, it might be wise to first make a test. Take two similarly exposed rolls and send one to the manufacturer or a known top quality lab; then use it for comparison with the other, processed locally.

Inexpensive color prints from transparencies are often disappointing because much brilliance is lost. You cannot expect too much from a $1.50 enlarged print when quality dye transfer prints—which get most out of the original—cost $150 for an 8 x 10 size. Ektacolor prints cost somewhat more than Kodacolor but are superior.

Buy fresh film: color balance changes as film ages. Throw away film near its expiration date, or you'll waste both your picture-taking time and the cost of processing. For professionals, the loss is tax-deductible. Avoid bargain processing, and use manufacturers' services whenever possible.

Color film gives best results when used in its intended light without conversion filters. Filtering daylight film for tungsten light is seldom desirable, nor is tungsten film filtered for daylight as good as using daylight film.

Darkroom Hints and Tips

A GREAT DEAL of picture quality can be lost in the dark-room. Good commercial black-and-white photofinishing is rare, and truly custom labs are expensive. To send Pentax pictures to a place geared to grind out jumbo prints from average cameras is like playing a fine hi-fi set through a $2.95 speaker.

The 35mm negative is a tiny and delicate thing, yet we know that when it is exposed properly in a camera like the Honeywell Pentax it is possible to coax brilliant and mag-nificent enlargements from it, even to sizes of 16 x 20 inches and larger. If you can't find someone to follow exact develop-ing instructions and make good prints, you'll have to nurse the film through your own darkroom. Otherwise, the full capabilities of your Pentax won't see the light of day.

There isn't space here to detail the basic steps of dark-room procedure, readily available in manufacturers' and other booklets. The best that can be done is to high-light some techniques that are important to good 35mm quality, set up a few guideposts, and give the kind of hints and tips that help many magazine photographers get the job done with simplicity and good quality.

The first problem is selection of film and developer. Many discussions about choosing a particular film for each subject, and the use of specialized developers, apply only to cameras which take one separate sheet of film at a time. Most amateurs and photo-journalists want as wide a variety of sub-jects and lighting as possible on one roll of 20 or 36 ex-posures, and still expect to get good quality. To reload various films for different situations is usually impractical.

In any event, while pursuing action, working quickly and seeking to use the special advantages of a 35mm camera, one cannot stop to consider the speed and special character-istics of several combinations of film and developer. That

P–47 pilots' reunion in dim ballroom, shot with Tri-X Pan rated at 1600 and Pentax H–3. Tall tale evokes disbelief of Republic executive.

would add too many variables to juggle in one's mind at the decisive moment.

Why simplify?

Of the many fine professionals who keep experimenting with new films and developers a surprising number persist with only one or two kinds. It is entirely possible to use only one or two black-and-white films and one developer, with today's 35mm materials, and not be severely restricted in most kinds of work. Limiting oneself gives a more foolproof standard for exposure and concentrates attention on the content of one's pictures. It helps guarantee success and enables you to gain a sure feeling for the way a scene will finally appear in a print. Later you may wish to play with less discernible and subtle differences among various films and developers, and then the experience with a standardized approach will have given you a basis for judging results.

Film versus developers

Unless a special personal interest dictates slower fine-grain films, there's more versatility and excitement in using the greatly improved medium and high speed emulsions. We've seen how far you can go with Tri-X Pan at ASA 400 or Ansco Super Hypan at ASA 500; with increased development these can be speeded up to a rating of 800 with only a small loss of quality. The grain size from that much "pushing" of film speed should not be objectionable in an 11 x 14 print. I've made 14 x 17's without offending fussy clients or editors. Developing in D–76 seems to me to bring out good contrast with Plus X Pan and Tri-X Pan, and while grain is larger than with some other developers it is also sharper at its edges and preserves a crisp feeling.

When you reach high ratings like 1200 the effect of pushing becomes quite apparent in lost shadow detail and increased contrast. The dim light must be even and diffused, or the scene itself must be one that is actually contrasty. However, some photographers take dramatic pictures at ratings up to 8000, using films like Agfa Isopan Record. If you want to try really "souping up" film, consult Y. Ernest Satow's book, "Pictures After Dark" (Amphoto, 1960). Satow also ably presents the case for choosing and using many different films and developers, and his other book, "35mm Negs and Prints" (Amphoto, 1962, rev. ed.) is a good basic guide.

Medium speed films rated at ASA 125 like Plus X shouldn't be pushed. They are superior wherever you don't need great speed, but when pushed, their already great contrast is exaggerated. Exposed and developed properly, they are capable of producing enormous blow-ups of good quality.

Years ago, I directed the magazine picture agency, Scope Associates, which was then made up of such photographers as Fons Iannelli, Lisa Larsen, Myron Ehrenberg, Morris Engel, Victor Jorgensen and Barrett Gallagher. Iannelli had set up the darkroom with rigid standards; film development was based primarily on one film, one developer and two film speeds. As each new photographer joined us he would advocate his own favorite films and pet developers, and each was accommodated—but only temporarily. These critical individualists soon came around to the uniform standard for 90 per cent of their shooting. Test comparisons with various favorites showed that the differences in speed and quality were almost impossible to detect.

I might add that Scope prints from negatives made this way by Charles Reiche in the late 1940's and early 1950's were greatly admired at *Fortune, McCall's, Ladies' Home Journal, Life* and most major magazines; they set a new standard of 35mm processing in the field. Some exacting photographers, like W. Eugene Smith, would trust their pictures only to Reiche when they couldn't handle processing themselves. Edward Steichen at the Museum of Modern Art wrote that he'd like to have us do all his exhibit prints—if the Museum could afford the prices. Only three simple materials were behind this reputation: Super XX film, D–76 developer and early Varigam enlarging paper.

Can one get such results in a home darkroom? With negatives, quite easily; good enlargements, frankly, take considerable experience, patience and skill—but you can learn quickly to make better prints than you can buy reasonably or readily. You can have fun doing it. You will save considerable money too. A good 8 x 10 can cost $1.50 or more. Finally, until you've made good prints yourself, you can't gauge what someone else is doing for you.

Film development

In the following suggestions, you can substitute any other reliable film and recommended developer; I mainly use

Eastman's which are universally available. First, three important points:

1. Develop each roll in an individual reel tank; trays are risky. Tanks that take several reels are difficult to agitate evenly, and the result can be more development at top and bottom, and streaks caused by bromide drain from heavy areas adjacent to light ones.

2. Agitate in a definite, always-repeated pattern. Give the tank a tipping, swirling or other motion so that each part of the film is bathed evenly. The best timing for this is five seconds every minute; more agitation not only speeds up development but can greatly increase contrast.

3. Throw away the used eight ounces of developer. Replenishers are a poor economy. Fresh developer gives best contrast and is consistent from roll to roll; used developer deteriorates rapidly and unpredictably.

Mixing and keeping developer is a nuisance if you don't use it often. The answer is to mix up a gallon in a bucket and pour into four one-quart plastic squeeze bottles; fill them to the stopper. In this relatively air-free condition and stored in a cool, dark place, developers such as D–76 should last a year. As you use it, squeeze the bottle until the liquid runs up to the top, excluding air, then cap it.

Development times

At 68° Fahrenheit (½ minute less at 70°)	
Tri-X Pan at ASA 400:	D–76 for 7½ minutes (full strength).
Tri-X Pan at 800:	D–76 for 8 minutes (full strength).
Tri-X Pan at 1200:	Acufine for 5¼ to 7 minutes; or UFG for 8½ minutes.
Plus-X Pan at ASA 125:	6 to 8 minutes in undiluted D–76.
Plus-X Pan at 64:	This film seems to take overexposure better than "pushing." Try this for more shadow detail, less contrast, fine grain. 4 to 6 minutes in undiluted D–76.

These times are less than those recommended by Eastman, which wants to make sure everyone gets an image, and must allow for those using diffusion enlargers which require more development and greater contrast than condenser enlargers. The above will give you better, thinner negatives—

if you read your exposure meter as I do mine; if not, you'll have to adjust slightly. Tri-X Pan seems to build overall density more quickly with increased development, while Plus X builds more contrast. Thus Tri-X is much more amenable to extended development.

Tips on procedure

It is best to first measure out the correct amount of developer, then pour it quickly into the tank.

The rinsing process can be speeded up by using hypo neutralizers. Temperatures of chemicals and rinse water should not vary more than 3° to 5° from each other, the less the better.

Hang washed rolls securely, weighted with a clip on the bottom to reduce curling. Drying time varies greatly with humidity, but only the gentlest heat should be used. Fans blow dust onto the negatives.

Handle wet film by unexposed ends or by the edges; even dry 35mm films should never be touched on the emulsion. The more you keep dust away from the film, the fewer your headaches later in spotting out the resulting white speck marks on prints.

Contact sheets

Cut the dried film into strips of six frames each and contact print them on 8 x 10 sheets of enlarging paper. The paper is laid under the enlarger on a board with a hinged sheet of heavy glass. The negatives are laid on the paper emulsion down and in numbered order, and the glass is let down to press them flat against the paper. Then, by using the projected light of the enlarger, it is possible to dodge, holding back any group of thinly exposed frames, and burning in any that are heavy. This method avoids the stocking of contact paper. Using variable contrast enlarging paper gives more flexibility in printing and also avoids your having to stock up on different contrast grades.

These sheets are the clue to your results, the key to your negative file, and your work-sheets before enlarging. Study them with a 5X or stronger magnifier for expressions, composition, fuzziness and mistakes. Then mark your selections with a grease pencil. You also crop out unwanted parts of the pictures on these proof sheets and second-guess the fram-

ing you used in shooting. Better pictures are sometimes found by severe cropping.

The Pentax negative records slightly more, on four sides of the frame, than you see in the viewfinder. This matches the cardboard framing mounts of color slides, sometimes saves a picture, but often requires a very slight cropping for prints.

Filing negatives

Don't keep your negatives in rolls; dust between the surfaces will grind into the emulsion. The whole roll will be subjected to this every time you want to print one negative. Dust-free glassine envelopes are all right for the six-frame strips if they open the long way, as business envelopes; the ones that open on the narrow end increase the amount of friction between the strips as you shake them out and push them back in.

Number and date each contact sheet, with corresponding data on the sleeve of negatives. You can keep track of a considerable file in this chronological fashion without the bother of an index. You might bunch up contacts and negatives, in their separate files, when they cover a particular subject or story, such as "Vacation, 1965," or "PTA Dance, Oct., 1964."

Making good enlargements

To produce a print that squeezes the most out of your 35mm Pentax negative combines artistry, skill and judgment. This takes practice indeed.

Good normal prints should have rich, black blacks and whites that are as white as the paper used. There should be a full scale of grays in between. If they are in the negative, there must be detail visible in the shadows or dark areas, and also in the white or highlight areas. The best example of the latter is a white shirt or dress; where there are folds, wrinkles or seams, some shadow or detail must come through; if there is texture, it should be seen. This is the kind of print you will see in museum exhibits and in well-printed photographic books and magazines.

Prints of this quality sing. They are brilliant. But one of the first things you will find is that they look much darker and more brilliant when wet in the developer, and under a

Tools for cropping: contact sheet, magnifier with light and grease pencil. Note cropping of frame upper right, reproduced on page 76.

safelight, than they do when dried and viewed under bright light.

The usual beginning in making prints is to cut a piece of enlarging paper into test strips and expose them to a cross-section of a negative for varying times.

The ideally-exposed print or strip will come up in the developer slowly to maximum density, reaching the correct point in 1½ to 2½ minutes, depending on the type of paper and developer.

If the print comes up too fast, you have overexposed in the enlarger and the picture will be muddy. To yank it before optimum development time will only make it soft, gray and lacking in contrast.

If your print comes up too slowly, you have underexposed and it will be too light. Forcing it in the developer increases contrast.

Slight changes in exposure and development times enable you to make slight changes in contrast, to improve an already good contrast and exposure. But a big change can't be made; you must go to the next contrast of paper, or to the next filter if you use variable contrast paper.

Now make a number of prints from the same full-scaled negative until you have a good exposure, and the print comes up in the developer within the recommended times.

If the print has sparkle, and those rich blacks and white whites, you may have a good one. But it would be wise to try some more. Now work toward using the *least* exposure and the *longest* recommended development time, until you can get the most brilliant print without losing a complete blackness in the black areas.

A really good printer seldom hits it on the first print, even with a good negative. A tough negative can require six or more tries. To achieve an exhibition print from even an easy negative, you can go on and on improving the result.

Your negative may require dodging—holding back a thin section—or burning in a dense one. Too general or pro-longed dodging can be ruinous—it can show too obviously in the print and often destroys its natural appearance.

Enlarging pointers

The quality of your enlarger should match your camera. Printing through anything less than a fine enlarging lens throws away the quality of your Pentax and Takumars. Few enlargers come properly aligned to make even 11 x 14 en-largements with perfect corner-to-corner sharpness. Check with a magnifier, focusing on grain in the corners of a nega-tive that is focused sharply in the center. You may have to adjust your enlarger, but first make certain that the negative lies flat in its carrier and that your easel is at an exact right angle to the enlarger.

Use the enlarger lens at apertures from f/5.6 to f/11. Get an enlarger with a glassless negative carrier—you will have four less surfaces to hold dust and no Newton ring prob-lems.

Ferricyanide is handy for lightening areas of prints, particularly under-exposed areas and faces.

Get accustomed to your safelight and always keep it at the same distance from the developing tray. Changing it can temporarily throw off your judgment.

Good print judgment comes slowly and is retained only with practice; good printers have trouble for several days after a vacation. Charles Reiche doesn't go out into bright sunlight at lunch time; it would spoil his eyes for the next hour's work.

Reiche, whom I would call a master printer, says: "Print to eliminate what you don't like. Crop, and then crop again on the easel. Soften and harden unpleasant details, but always manipulate with restraint. The reality in front of the camera can't be tampered with too much; the best you can do is restore certain elements that have been over- or under-emphasized. Tricks are not only phony—they show."

CHAPTER XI

Necessities and Accessories

As YOUR INTERESTS diversify, the Pentax can grow with you through accessories. The Honeywell items mentioned here are also listed, with prices, at the end of the book.

Exposure meters

A general purpose exposure meter of some kind is a basic necessity. The more sensitive, legible and wide in range of exposure settings it is, the more you will be able to do and the greater your exposure accuracy. Two meters are of special interest to owners of non-Spotmatic Pentaxes.

The first is a small, clip-on meter for the recent Pentaxes that couples to the shutter speed dial. It is held firmly in the grooves of the viewing window, and rests over the reflex housing. You set your film speed rating and shutter speed, then read the aperture from the meter. Or, you decide on the f-number you want and turn the shutter speed dial until that aperture is in line with the meter's needle.

This reflected light meter has a lens that limits its field of view to 40°, approximately the area covered by a 55mm lens. This makes it possible to read accurately the light on medium distance as well as close subjects without picking up peripheral light. It can be set for ASA speeds from 6 to 1600, and naturally covers all Pentax shutter speeds and apertures.

This meter is so sensitive that it will register direct light coming through your finger from an ordinary electric light bulb. This sensitivity comes from its cadmium sulfide cell, powered by a tiny 1.3-volt mercury battery which lasts approximately a year.

An advantage is that the meter attaches and detaches instantly and can be used off the camera as well as coupled.

Pentaxes made after mid-1961 come with the necessary coupling slot cut into the shutter speed dial. Earlier H–1

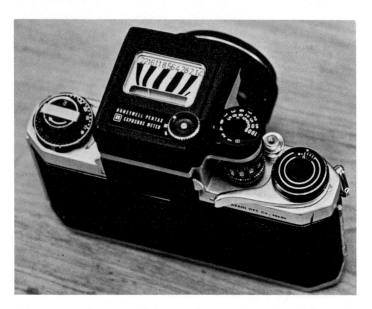

The sensitive, clip-on, coupled meter shown on the Pentax H–3v model.

and H–3 models are easily refitted with the new inexpensive dial by dealers handling the meter, camera repair shops and Honeywell Service Centers.

The 1°/21° Honeywell meter

The new and really unique Honeywell Pentax 1°/21° meter gives you precise and selective readings, and it is sensitive to extremely low light levels. It actually reads light in an area so tiny that you are in effect using a lens of over 2000mm lens to pick out the exact spot from which you wish to determine exposure, nearby or distant.

When you sight through the eye-level 1°/21° meter you see a 21° field of view. In the center of this finder is a small circled target area with only a 1° angle of view; this is what the meter reads. Thus you can take a precise reading on a person's face from across a broad street or get the reading on a distant performer in a spotlight. It allows you to pick out the various elements in a scenic shot for separate readings —a white house, a shaded place under a tree, a distant hillside. This is valuable for color, where you should not have more than a three-stop spread between important areas, or

104

whenever you wish to expose for one area and not another.

This meter is a special boon to all long-lens photography since it always reads less than the lens includes in its view. In places where light keeps changing, as in theaters, it is indispensible for accuracy. The range of measureable exposures is from four minutes to 1/4000 second, with apertures from f/1 to f/128. Its ASA range is from 6 to 6400.

The Pentax 1°/21° meter operates for a year on one 1.3-volt mercury battery and one nine-volt dry cell.

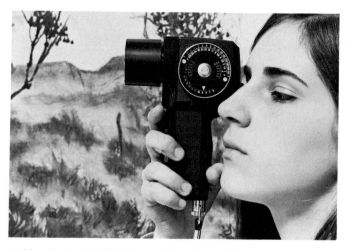

Highly selective 1°/21° Pentax Meter for small spot and distant measurement.

Reading new meters

In using selective meters, care should be taken that the light is read from something of the proper or average brightness, or that you average a series of readings. With older wide angle meters it was important to read close to objects to avoid peripheral light; with the new narrow angle meters the entire scene must be considered.

When extremely long exposures are required, usually in very dim light, the film does not respond normally and more exposure is required than a meter would indicate. According to David Eisendrath's researches, a one-second exposure on Kodak 35mm black-and-white films should be given approximately one-third of an f-number additional exposure. When

exposure time is ten seconds, this becomes a full f-number additional, and at 30 seconds it becomes two full f-numbers. The aperture increase for High Speed Daylight Ektachrome is approximately: two-thirds of an f-number at one second; one and two-thirds at ten seconds; two f-numbers at 90 seconds.

Lens hoods

Pentax lens hoods are designed to give maximum shading without cutting off the corners of pictures. More lenses now come with their own hoods, made so that they fit reversed over the lens in its case or are built onto the lens.

Lenses requiring special hoods that are not supplied are those of 35mm, 50mm and 55mm.

Selecting Pentax filters

Pentax optical-glass filters are precision ground, polished and coated. Eleven types of filters are available for the more popular lenses which take 46mm and 49mm filters, while at least four are available for every lens. A listing by size is given in the back of this book.

Wherever possible, the designers have made the new Super-Takumars so that they accept the same 49mm filter, a great savings for filter addicts and a convenience for those who carry them. This size fits the 35mm f/3.5 Super, 50mm and 55mm, 105mm Super, the 135mm f/3.5 Super, the 150mm Super, the 200mm f/5.6, the Macro and Bellows Takumars and the newer 28mm f/3.5 Super.

A selection of four of the most popular filters is now available for all lenses, the UV, Medium Yellow, Medium Orange and Skylight. Here is a complete list with their main uses.

Filters for black-and-white film are:

The UV filter cuts haze (not fog or mist) by absorbing unseen ultraviolet rays only. It reduces the blue effect in open shade which often mars color pictures. Ultraviolet is not seen by the eye but registers as blue on color film, haze on black-and-white. Since this filter is helpful outdoors with both kinds of film, and does not increase exposure time, it is often left on the lens for protection and because it can be wiped clean of dust and moisture rather than the lens.

The Y1 Yellow filter absorbs a moderate amount of blue, increases contrast slightly and emphasizes white clouds against blue sky. Filter factor is 1.5.

The Y2 Medium Yellow filter absorbs more blue, accentuates effect of Y1 filter. Factor is 2.

The O2 Light Orange filter absorbs both ultraviolet and blue, is used for marine and aerial pictures to get somewhat exaggerated contrast into otherwise flat scenes. Filter factor is 3.

The YG Yellow-Green filter renders more pleasing and natural skin tones than yellow filters, especially when taking portraits against a blue sky. Filter factor is 2.

The Medium Red filter is used with infra-red film or with panchromatic film to achieve dramatic effects, extreme contrast. Cuts through fog and mist as well as haze. Filter factor is 6.

Filters for color are:

Skylight absorbs blue and adds warmth to skin tones. Reduces blue from sky in open shade. Filter factor is 1.

Cloudy (81A) absorbs more blue than Skylight. Filter factor is 1.5.

Morning & Evening (82A) cools down the warm, reddish light of early morning and late afternoon sunlight. Filter factor is 1.5.

Flash (80C) has more "cooling" effect than above, also is used with daylight color film and clear flash bulbs. Filter factor is 2.

Flood (80B) is for "cooling" light of ordinary 3400°K photofloods when using daylight color film. Filter factor is 3.

Two Pentax cases

A difficult choice must be made between two thoughtfully designed and functionally different cases for your Pentax. One is of handsome, soft black leather and the other is of stiff, black leather. There is no question that the latter gives more protection, but the soft one is the handsomest case you can find.

The rugged hard case has certain features that fit it better for all-around amateur use. While the tops of both slip off quickly, the bottom of the hard case is fixed securely to the camera, and the neck strap is attached to the case and not to the camera body. Thus, the bottom is meant to be left on while shooting. It is held on by a knob with a screw to the tripod bushing, and this case has its own tripod bushing.

The top part of the soft case is collapsible, for easy stuff-

ing into the pocket. It also allows you to carry an inverted hood over the standard lens. The neck strap is attached to the camera, so that you can carry it with the bottom of the case on or off. The bottom is held on by a short snap-strap across the camera so that it slips off quickly for fast reloading. Incidentally, it is always wise to wear a neck strap as short as possible, both to keep the camera readier for quick shooting and to prevent it swinging around and banging into things.

Special models of these cases are now available to fit the cameras when the shutter-coupled exposure meter is left in place. Spotmatics take a special soft, black leather case.

Tripods

A tripod is a valuable inconvenience, but don't let it become a crutch, holding you down to static pictures and stilted poses of people, or an anchor that prevents moving about while composing or trying to follow action. It is unnecessary for most kinds of 35mm photography, but when it is needed you must have a sturdier one than for a heavy camera.

When you buy a tripod, spend at least $25 and get one as rock-solid as possible, yet with a weight that won't discourage its use. Make sure the head will tilt all the way over to point your camera straight down; this will also hold it for pictures in the vertical position. A tripod without a rising center post is a three-legged annoyance—you'll have to tip it up and re-adjust all three legs for each change in height. The center post also gives you extra height with a lighter and shorter tripod. Really light weight and collapsible tripods are not sturdy.

Ultra close-ups

Convenient tubes, bellows and other devices for ultra-close-up photographs are covered in the next chapter.

Right Angle finder

Useful in close-up work and other specialized situations, the Pentax Right-Angle Finder is an optical viewing acces-

sory that slips onto the grooves in the viewfinder window. It converts the camera to waist-level viewing, or to any other angle parallel to the back of the camera. If you are likely to shoot from tight corners, or from ground level, or do such odd things as mount your camera on a center post turned upside down in a tripod for low-level shooting, this device lets you see into the viewfinder.

If you ever have to shoot high, holding the camera over your head, or put it atop a tripod higher than your eye, this finder may help. It swivels through 180°, but can be slipped on upside down to cover the rest of a full 360° circle. It might be used for sneak pictures, if you want to deceive people by facing in a different direction than you are aiming the camera. It does reverse the image from right to left, but keeps it upright. There is also a Pentax clip-on magnifier which enlarges the viewfinder image.

Microscope adapter

The Honeywell Pentax adapter for photomicrography can be used with microscopes having tubes of 25mm diameter. The lens is removed from the camera and the microscope's optics are utilized.

Prescription eyepiece

This inexpensive item is designed to accept a prescription lens so that many eyeglass wearers can take off their glasses and view more clearly. It fits onto the grooves of the viewing window. The lens can be fitted into it easily by an oculist, to your prescription. If your problem is astigmatism, however, it will not work in the vertical position. One photographer has had the eyepiece rebuilt to swivel 90°; others use contact lenses.

Reproducing your color

A really enticing prospect for the color slide enthusiast or the film-strip professional is to be able to copy his color slides in accurate color rendition. If he could also make color corrections to improve the original, crop out unwanted parts of transparencies while enlarging the remainder to full-frame, and make unlimited duplicates, would his cup not runneth

109

Accessory eyepiece for prescription lens.

over? Suppose he could also reduce most of a 2¼ transparency to 35mm slide size? And do all kinds of vignetting and trickery in reproducing a slide?

Well, the price of this bliss is $435 for the only device that does the job, the Honeywell Repronar.

The Repronar is a great combination of electronic engineering, electronic flash, and a special Pentax camera. Its light source is a Strobonar powered by house current and it uses a specially designed 50mm f/3.5 copying lens. It comes with a complete set of accessories, including filters for correction and various slide holders.

With the Repronar you can correct not only for some over-exposure and under-exposure, but for color balance. You can add or subtract over-all color. You can enlarge one-quarter of a transparency to full-frame size. You can reduce parts of large-size transparencies to 35mm slides, and make color or black-and-white negatives from color slides. You can dodge, tilt, vignette, add titles, make montages and produce and duplicate film strips. Go Into Business For Yourself! Make Money at Home! Double Your Income in Your Spare Time!

Bulk-loading cartridges

If you shoot a large amount of a special type of film, it may pay you to buy 50- or 100-foot bulk-load lengths. It

once was possible to reload cassettes from store-bought film. Now many of them are sealed more tightly and safely but cannot be closed again for reloading.

Bulk loading is risky unless done carefully and unless the cassettes are undamaged and free of dust. Honeywell supplies finely made film cassettes at $4.95 apiece that can be re-loaded indefinitely with more ease and safety. If you shoot a lot—and reload a lot—you may be able to amortize the in-vestment in a half-dozen of them.

Repronar unit will copy transparencies, and make black-and-white nega-tives from them, has own light source.

The World of the Ultra Close-Up

AN INTRIGUING MICROCOSM of things and creatures awaits the interested owner of a Honeywell Pentax, for whom tiny objects, insects and flowers can be photographed very simply and enlarged or projected to monstrous size.

Basically, all that one needs is one accessory to get started: a close-up lens for moderate magnification and complete simplicity; a set of extension tubes for reproducing a subject up to life-size on the negative; or, one of two Pentax extension bellows. From there one can go on to add refinements, helpful devices, and a special macro lens to pursue small subjects in a big way.

Using either extension tubes or bellows you can photograph a half-inch insect and blow it up in a print to ten inches —or larger. If someone engraves the Lord's Prayer on the 1/16 inch head of a pin for you it can be enlarged to almost three inches with fine grain film. Color slides made in this way and projected can be awe-inspiring indeed.

Pentax single-lens viewing makes such close-ups easy by showing in the finder exactly what the extended lens sees. You view without parallax, focus the actual lens on the actual subject, and you also see depth—or rather, at close distances, the lack of it.

A set of three different-length Pentax extension tubes gives you seven combinations for magnifications up to slightly larger than life-size on the negative. You can enlarge such a picture to at least 15x life-size.

With Pentax bellows extensions you get a continuous range of magnifications. Bellows I goes up to 2.4x life-size and Bellows II to 3.2x life-size on the negative. The first is

Half-inch tip of fern frond showing spores and some spore cases thrown off against a black background. Shown here magnified over ten times. Pentax H–3v was used with Bellows I and 55mm f/1.8 lens. Tri-X Pan film.

an inexpensive single-track device while the Bellows II is a professional and much more versatile model with two sturdy tracks. Both the rear, or camera, end of the Bellows II and the front, or lens end, can be moved. It has tripod mounts both front and rear. Bellows II also takes a slide copying holder. It is calibrated to show the amount of bellows extension, and the instruction booklet lists exact magnifications, subject sizes for different lenses, and the proper exposure factors.

Short "extension" course

As soon as a lens is extended for close-up work, exposure must be increased. The author has worked out a simplified table for the extra exposures that are necessary. It works for any tube or bellows extension and for lenses of different focal lengths. To use it you need only measure or estimate either the width or length of the subject area, or know the degree of magnification. The table then gives the exposure factor needed and the equivalent in increased f-numbers required.

Simplified Exposure Guide for Ultra Close-Ups
with Bellows and Tube Extensions
For any focal length lens

Subject area (approx)*		Magnification	Exposure factor	f-number increase
4 x 6	inches	0.25	1.5	½
2 x 3	"	0.50	2	1
1⅓ x 2	"	0.75	3	1½
1 x 1½	"	1.00	4	2
⅔ x 1	"	1.50	6	2½
½ x ¾	"	2.00	9	3
⅜ x ⅝	"	2.50	12	3½
⅓ x ½	"	3.00	16	4
¼ x ⅜	"	4.00	25	4½

*For simplicity it is considered that the negative frame is 1 x 1½ inches, and that it represents a 1 x 1½ inch subject as life size. Actually, the negative is 1.41 x .94 inches. This difference will have no perceptible effect on exposure. Honeywell supplies precise and complete tables for a variety of focal lengths with each bellows unit and set of extension tubes.

With extensions that produce a life size or larger image, depth-of-field is literally measured in hundredths of an inch. The smallest apertures are usually required; subjects cannot have too much depth, focus is critical, moving subjects are difficult. Nevertheless, you can often hand-hold the camera

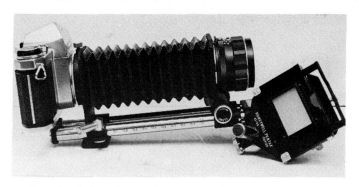

Extension Bellows II magnifies to 3.2X. Shown with slide copier.

with a #1 or #2 extension tube in bright sunlight for slow-moving subjects. The problem in hand-holding is not camera shake so much as critical focus on shallow depth.

For hand-held close-ups you do not focus, but set aperture and focus in advance and then move the camera in until your subject is sharp. Fast-moving subjects, like most insects, must be brought under control; a tiny glass "aquarium" under careful lighting is often used, or they can be made sluggish in the refrigerator. Dead insects look dead and are much less interesting. Flowers should usually be picked and shot in an area shielded from wind; stuck in a can of soil they can be manipulated more easily.

Usually, to get depth plus speed plus the fine grain of slower films, a sturdy tripod is necessary. You must always remember to set apertures manually, since with these extensions the automatic lens diaphragm pin does not connect to the camera body. It is often handy, however, to use the automatic lever as a quick preset lever to open up for focusing and then to close-down to the selected f-number for shooting.

The problems of calculating exposure at any extension are eliminated if you have a Spotmatic Pentax. Its meter of course reads the exact light that will reach the film regardless of extension.

The Macro-Takumar

The 50mm Macro-Takumar f/4 is an almost universal lens, focusing from infinity to as close as 2⅛ inches (eight inches from the film plane). At the closest distance it repro-

115

duces a subject at 1:1, or life-size on the approximately 1 x 1½ inch negative. We can see its convenience if we take our Pentax and this lens alone for a walk to a park, woods, zoo or botanical garden; with a few twists of the focusing ring we can photograph broad scenic views and then close in on tiny flowers, insects or an animal's eye.

The Macro-Takumar is a preset lens that closes down to f/22. It has an extremely flat field which, as we will see, is important with macro subjects that are flat. Calibrations on the lens barrel tell the magnifications you get at various distances, and these are color-coded with index marks so that you can easily reset apertures for exposure compensation.

An ideal combination is the Macro-Takumar on a Pentax Spotmatic, which enormously simplifies macro work by indicating precisely correct exposure instantaneously. With this lens on Bellows II you can enlarge subjects to over 4x on the negative; blown up less than 15x further in enlargement you can magnify things 60x, which brings you into the preserve of low-power microscopes.

A more specialized lens for macro work is the 100mm f/4 Bellows-Takumar. It is focused by racking the bellows in and out, reaching from infinity to close enough, with the Bellows II, for magnifying to almost 1½x life-size. It also has a very flat field and closes down to f/22. While it magnifies less than shorter focal lengths, it leaves lots of room between lens and tiny subjects. This is helpful in lighting, when trying to get close to shy insects or small animals, and also makes it a good lens for portraits.

The supplementary Pentax Close-Up Lens ($11.50) screws onto lenses with 49mm front threads. It allows focusing a 55mm lens to 11 inches (from film plane to subject) instead of its normal 18 inches, and gives magnifications up to .32x. This gives a considerably enlarged picture, since the subject area at closest distance is reduced to 4 x 2¾ inches, roughly one-quarter of the area covered by the lens without it. A more powerful close-up lens would not give as sharp pictures as you can get by extending the lens. The big advantages of the close-up lens are that no change is required in exposure, and the camera lens remains automatic.

Reversing the lens

When a standard lens is extended so that it is closer to the subject than it is to the film plane, its curvature of field

gradually becomes exaggerated. This will become apparent in pictures of flat subjects like postage stamps when the edges begin to go out of focus, especially as you approach magnifications of 1:1. This is one of the reasons for using a macro or bellows lens. There is another answer: reversing the standard lens. This greatly flattens the field, and it also extends the lens slightly, gives somewhat greater magnification and leaves a little more room in ultra-close-ups for lighting the subject. It is slightly awkward for hand-held close-ups or fast working, since aperture and focusing rings are reversed and lens markings are upside-down. The Pentax Reverse Adapter ($2.95) allows this to be done with most Takumars having 49mm front threads: the 35mm f/3.5, the 50mm, 55mm, both 105mm and both 135mm lenses.

Extension tubes have two uses on telephoto lenses, since they reduce the minimum focusing distance and make larger images possible at close distances. A close-up of a nest of live wasps, for example, is inadvisable with a short or normal focal length lens. But a 200mm lens requires you to be at

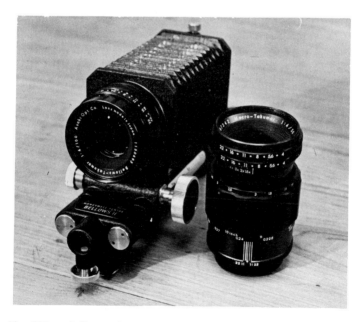

The 100mm Bellows-Takumar f/4 lens (left), on Bellows II, and 50mm Macro-Takumar f/4 (right). Latter focuses from 2⅛ inches to infinity.

least nine feet away, which makes the wasps too small to be seen. A #1 or #2 extension tube on the longer lens allows you to be four or five feet away—hopefully safe—yet able to see the wasps.

Using a 300mm lens to photograph small birds at a nest or feeder requires you to be 18 feet away, the closest focusing distance. With a #2 tube you can move in to nine or ten feet and get an image of the bird that is twice as big. Note, though, that depth of field shrinks, too, and that with an extension on the lens it will no longer focus to infinity. Extra exposure must be allowed for the amount of extension.

Photofloods are best for still-life subjects, while live subjects make electronic flash ideal. Often bouncing either light is the best, and you can use sheets of white cardboard near the subject to reflect the light into the tight space between it and the lens.

Certain scientific fields and medical, surgical, dental and eye studies call for a light without shadows in ultra-close-ups, and exact color rendition. Here a "ring light" such as Honeywell's Prox-O-Lite is the answer. It can be powered from its own or another electronic unit's power pack.

NOTE: The Macro lens now comes in an automatic version, and there is a set of automatic extension tubes.

CLOSE-UP DEPTH-OF-FIELD TABLE

for 55mm Takumars
(Distance scale set at 1.8 feet)

f/setting	f/2	f/2.8	f/4	f/5.6	f/8	f/11	f/16	f/22
Exten. tube combin.								
#1 (inches)	9.45 -9.53	9.45 -9.53	9.41 -9.53	9.41 -9.57	9.33 -9.61	9.29 -9.65	9.21 -9.76	9.13 -9.88
#1 plus #2 (inches)	5.43 -5.47	5.43 -5.47	5.43 -5.47	5.43 -5.47	5.39 -5.51	5.39 -5.51	5.35 -5.55	5.35 -5.55
#1, #2 and #3 (inches)	3.39 -3.39	3.39 -3.39	3.39 -3.39	3.39 -3.39	3.39 -3.39	3.39 -3.43	3.35 -3.43	3.35 -3.43

The above table is in inches. Figures 3.39–3.39 mean that the depth of field is less than 0.01 inches. Subject distance is measured from the front frame of lens.

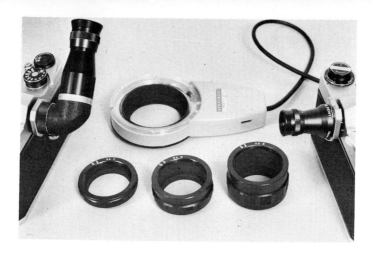

Close-up accessories include right-angle finder at left, 2X magnifier, right, a set of extension tubes and electronic flash Prox-O-Lite.

Chrysanthemum? No, a dandelion enlarged with three Pentax extension tubes. Sunlight, ASA 64, 1/60 at f/11, 55mm Takumar on H-3.

DEPTH-OF-FIELD TABLE FOR SUPER AND

AUTO-TAKUMAR 55mm LENSES

*Note: The area within the dark rule applies to the 55mm f/2.2 lens.
The table from f/1.8 to f/16 applies to the 55mm f/1.8 lens.*
*The depth-of-field distances below are expressed in feet, and the distance is
measured from the film plane.*

F Setting	30 Ft.	15 Ft.	10 Ft.	7 Ft.	5 Ft.	4 Ft.	3.5 Ft.	3 Ft.	2.5 Ft.	2.25 Ft.	2 Ft.	1.7 Ft.	1.5 Ft.
F/1.8	25.3 / 36.9	13.7 / 16.5	9.4 / 10.6	6.72 / 7.30	4.86 / 5.15	3.91 / 4.09	3.44 / 3.57	2.95 / 3.05	2.47 / 2.53	2.23 / 2.27	1.98 / 2.02	1.69 / 1.71	1.49 / 1.51
F/2	24.8 / 37.9	13.6 / 16.7	9.4 / 10.7	6.70 / 7.33	4.85 / 5.16	3.90 / 4.10	3.43 / 3.57	2.95 / 3.05	2.47 / 2.54	2.22 / 2.28	1.98 / 2.02	1.68 / 1.71	1.49 / 1.51
F/2.2	24.4 / 38.9	13.5 / 16.9	9.3 / 10.8	6.67 / 7.37	4.83 / 5.18	3.90 / 4.11	3.42 / 3.58	2.94 / 3.06	2.46 / 2.54	2.22 / 2.28	1.98 / 2.02	1.68 / 1.71	1.49 / 1.51
F/2.8	23.2 / 42.3	13.1 / 17.5	9.1 / 11.0	6.58 / 7.45	4.79 / 5.23	3.87 / 4.14	3.40 / 3.61	2.93 / 3.07	2.45 / 2.55	2.21 / 2.29	1.97 / 2.03	1.68 / 1.72	1.49 / 1.51
F/4	21.2 / 51.4	12.5 / 18.9	8.8 / 11.5	6.42 / 7.70	4.70 / 5.34	3.81 / 4.21	3.36 / 3.65	2.90 / 3.11	2.43 / 2.57	2.20 / 2.31	1.96 / 2.04	1.67 / 1.73	1.48 / 1.52
F/5.6	19.0 / 72.1	11.7 / 21.0	8.4 / 12.3	6.21 / 8.03	4.60 / 5.48	3.75 / 4.29	3.31 / 3.72	2.86 / 3.15	2.41 / 2.60	2.18 / 2.33	1.94 / 2.06	1.66 / 1.74	1.47 / 1.53
F/8	16.4 / 182.2	10.7 / 25.4	7.9 / 13.7	5.93 / 8.57	4.44 / 5.72	3.65 / 4.43	3.23 / 3.82	2.81 / 3.22	2.37 / 2.65	2.15 / 2.36	1.92 / 2.09	1.65 / 1.76	1.46 / 1.54
F/11	14.1 / ∞	9.6 / 34.5	7.3 / 15.9	5.61 / 9.36	4.27 / 6.05	3.53 / 4.62	3.14 / 3.96	2.74 / 3.32	2.32 / 2.71	2.11 / 2.41	1.89 / 2.12	1.63 / 1.78	1.45 / 1.56
F/16	11.3 / ∞	8.3 / 85.3	6.5 / 21.7	5.14 / 11.8	4.00 / 6.70	3.35 / 4.98	3.00 / 4.21	2.64 / 3.49	2.25 / 2.81	2.05 / 2.49	1.85 / 2.18	1.60 / 1.82	1.42 / 1.59
F/22	9.2 / ∞	7.1 / ∞	5.8 / 39.1	4.68 / 14.23	3.73 / 7.70	3.16 / 5.49	2.85 / 4.56	2.52 / 3.72	2.17 / 2.95	1.99 / 2.60	1.80 / 2.26		

Honeywell Pentax cameras and accessories

CAMERAS

880. Honeywell Pentax Spotmatic, with 50mm f/1.4 Super-Takumar, satin chrome finish. $299.50.

882. Honeywell Pentax Spotmatic, same as above, satin black finish. $309.50.

884. Honeywell Pentax Spotmatic, with 55mm f/1.8 Super-Takumar, satin chrome finish. $259.50.

— Honeywell Pentax SL, with 55mm f/1.8 Super-Takumar, satin chrome finish. About $200.00.

705. Honeywell Pentax H-1a, with 55mm f/2.0 Super Takumar, satin chrome finish. $159.50.

CAMERA BODIES ONLY

881. Honeywell Pentax Spotmatic, satin chrome. $189.50.
883. Honeywell Pentax Spotmatic, satin black. $199.50.
828. Honeywell Pentax H-1a, satin chrome. $109.50.

CAMERA CASES

887. Soft black leather case for Spotmatic. $17.50.
867. Black hard leather case for Spotmatic. $17.50.
751. Soft black leather case for H-1, H-3, H-1a and H-3v. $15.00.
740. Black hard leather case for H-1, H-3, H-1a and H-3v. $17.50.
753. Soft leather case for use with H-1, H-3, H-1a and H-3v with clip-on meter attached. $17.50.
7093. Top half of above case; for converting standard case to accept Pentax Camera with clip-on meter attached. $10.50.

TAKUMAR LENSES

Lenses designated "Super" are fully automatic; those marked simply "Takumar" are either preset or manual. Front and rear lens caps and leather cases supplied with each lens. Lens hoods come with all lenses of 85mm and longer and fit into case with lens.

7080. 17mm Super-Takumar, f/4.0. $239.50.
7081. 28mm Super-Takumar, f/3.5. $149.50.
7086. 35mm Super-Takumar, f/2.0. $189.50.
742. 35mm Super-Takumar, f/3.5. $94.50.
825. 50mm Macro-Takumar, f/4.0. $114.50.
7084. 50mm Super-Macro-Takumar, f/4.0. $139.50.
879. 50mm Super-Takumar, f/1.4. $121.00.
737. 55mm Super-Takumar, f/1.8. $81.00.
736. 55mm Super-Takumar, f/2.0. $61.00.
827. 70 to 150mm Zoom Super-Takumar, f/4.5. $395.00.
870. 85mm Super-Takumar, f/1.9. $169.50.
826. 100mm Bellows-Takumar, f/4.0. $84.50.
738. 105mm Super-Takumar, f/2.8. $129.50.
743. 135mm Super-Takumar. f/3.5. $149.50.
7082. 135mm Super-Takumar, f/2.5. $169.50.
893. 150mm Super-Takumar, f/4.0. $149.50.
872. 200mm Super-Takumar, f/4.0. $189.50.
719. 200mm Tele-Takumar, f/5.6. $119.50.

728. **200mm Takumar, f/3.5.** $159.50.
7083. **300mm Super-Takumar, f/4.0.** $339.50.
824. **300mm Takumar, f/6.3.** $159.50.
729. **300mm Takumar, f/4.0.** $279.50.
894. **400mm Takumar, f/5.6.** $319.50.
822. **500mm Takumar, f/4.5.** $450.00.
868. **1000mm Tele-Takumar, f/8.** $1195.00.
869. **85mm Quartz Takumar f/3.5.** $550.00.

EXPOSURE METERS

718. Honeywell 1°/21° exposure meter. Has own optical reflex viewing system and extreme selectivity and accuracy. Light-sensitive cell (cadmium sulfide) covers an angle of only 1° and is defined in the center of a viewing screen with a 21° angle of view. Light intensity is read directly on the viewing screen, and exposure is calculated on movable rings on the lens barrel. Complete with batteries and leather carrying case. $129.50.

895. Honeywell clip-on meter. Easily attached to pentaprism housing of Honeywell Pentax cameras, this meter couples directly to slotted shutter speed dial. Cadmium sulfide cell offers high sensitivity; measures an angle of only 30°. Complete with battery and leather carrying case. $29.50.

MACRO, MICRO AND COPY EQUIPMENT

7094. Extension tube set for current Pentax models. Three rings, 9.5mm, 19.0mm and 28.5mm. With 55mm lens magnifies subjects larger than life-size on negative. $19.50.

786. Bellows unit I. Single track with calibrated gear shaft. Continuous magnification from 0.62 to 2.45 times life-size with 55mm lens. $29.50.

832. Bellows unit II. Double track, locks in any position; both camera and lens can be moved forward or backward. Magnifications to 3.2 times life-size with 55mm lens. $59.50.

834. Slide copier for above. Slide stage raises and lowers for exact positioning. Separate bellows shuts out light between lens and slide. $29.50.

787. Microscope adapter. For use with any microscope having tube diameter of 25mm. $25.00.

798. Clip-on magnifier. Attaches to viewfinder and enlarges image 2x. $11.95.

788. Right-angle finder. $29.50

821. Close-up lens. Screw-in mount for lenses with 49mm thread, or 46mm with adapter #820. Allows focusing to 11 inches with 55mm lens, magnifies subject 0.32 to 0.15 times. $11.50.

717. Copipod. Lightweight, rigid, portable copying stand fits all Pentaxes. For copying documents, artwork, stamps, etc. Lensboard complete with adapter rings for lenses with 46mm or 49mm threads. Has four calibrated, telescoping legs. With case. $24.50.

755. Pentax Reverse Adapter for lenses with 49mm front thread. $2.95.

FILTERS

There are eleven types of filters available for Pentax lenses with front threads of 46mm and 49mm: ultraviolet, light yellow, medium yellow, medium orange, yellow-green, medium red, skylight, cloudy (80A), morning and evening (82A), flash (80C), and flood (80B).

The following sizes of filters are available in four types: ultraviolet, medium yellow, medium orange, and skylight.

Filter	Lens
58mm	85mm Super f/1.9
	135mm Super f/2.5
	200mm Super f/4
	300mm manual f/6.3
67mm	70mm-150mm Super Zoom
	200mm preset f/3.5
70mm slip-on	35mm Super f/2
77mm	300mm Super f/4
	400mm manual f/5.6
82mm	300mm manual f/4

MISCELLANEOUS

789. Cable release, 10 inches, floating collar, locking set screw for time exposures. $2.50.

790. Leica adapter A, for use with lenses having same mount as Leica on Pentax bodies. For close-up photography only. $6.95.

791. Leica adapter B, for using Pentax lenses on Leica-mount camera bodies. For close-up photography only. $6.95.

793. Accessory clip, slips into grooved slot on viewfinder to support shoe-mounted accessories. $2.95.

781. Rear lens cover. $1.75.

794. Cap for camera body. $1.75.

747. Self-timer. $7.95.

795. Film magazine (cassette) for loading bulk film. $4.95.

796. Clip-on prescription eyepiece for holding prescription lens. $2.95.

The following are Honeywell Pentax service centers:

Honeywell Photo Products
5501 S. Broadway
Littleton, Colo. 80120

Honeywell, Inc.
24-30 Skillman Ave.
Long Island City, N. Y. 11101

Honeywell, Inc.
7120 N. Lawndale Ave.
Lincolnwood, Ill. 60645

Honeywell, Inc.
6620 Telegraph Road
Los Angeles, Calif. 90022

The following are authorized Pentax repair stations:

Arizona Camera Repair
Phoenix, Ariz.

Purchase Camera Repair
Ann Arbor, Mich.

Mel Pierce Camera
Hollywood, Calif.

Midwest Camera Repair
Wyandotte, Mich.

Strauss Photo-Technical
Washington, D. C.

Capitol Camera Repair
Lincoln, Neb.

Dan's Camera Clinic
Southern Photo-Technical
Miami, Fla.

Capitol Camera Repair
Omaha, Neb.

Southern Photo-Technical
Jacksonville, Fla.

Mack Camera Service
Union, N. J.

Southern Photo-Technical
St. Petersburg, Fla.

Charles S. Smith, Jr., and Co.
Camera Service Company
Atlanta, Ga.

Camera Repair Service
Oak Park, Ill.

Murphy's Camera & Projector
New Orleans, La.

Sanford Photographic
Industries
Boston, Mass.

Precision Camera Repair
Chicopee Falls, Mass.

Continental Camera Repair
Buffalo, N. Y.

Southern Photo-Technical
Charlotte, North Carolina

Zink Camera Repair
Akron, Ohio

Comet Camera Repair
Philadelphia, Pa.

Larry Work Photographic
Dallas, Texas

Boyd's Camera Repair
San Antonio, Texas

Photo-Tronics, Inc.
Seattle, Wash.